Images of Modern America

PHILADELPHIA MUMMERS

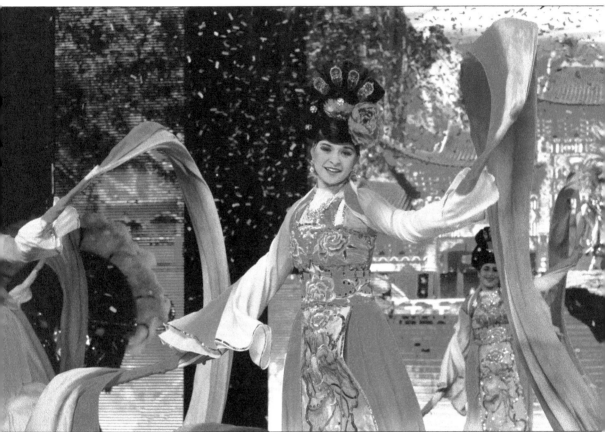

Mummers create colorful, mystical imagery both in the outdoor parade and the indoor shows on New Year's Day, as seen above in the South Philly Vikings Fancy Brigade 2015. Its theme was "Day of the Avatar: Master of the Elements." The clubs of the Fancy Brigade Division perform two shows on New Year's Day inside the Pennsylvania Convention Center, located a couple of blocks from the outdoor parade. The second show is the one that is judged. The Vikings won first prize in their division in 2015. (FBA.)

FRONT COVER: John Baron, captain of Hegeman String Band on New Year's Day 2015 (PHL17)

UPPER BACK COVER: A young Mummer outside Philadelphia City Hall (PHL17)

LOWER BACK COVER (from left to right): A Fancy Mummer (PHL17), String Band Mummer (PHL17), Fancy Mummer (PHL17)

Images of Modern America

PHILADELPHIA MUMMERS

Stephen M. Highsmith

ARCADIA
PUBLISHING

Published by Arcadia Publishing
Charleston, South Carolina

Library of Congress Control Number: 2016950305

For all general information, please contact Arcadia Publishing:
Telephone 843-853-2070
Fax 843-853-0044
E-mail sales@arcadiapublishing.com
For customer service and orders:
Toll-Free 1-888-313-2665

Visit us on the Internet at www.arcadiapublishing.com

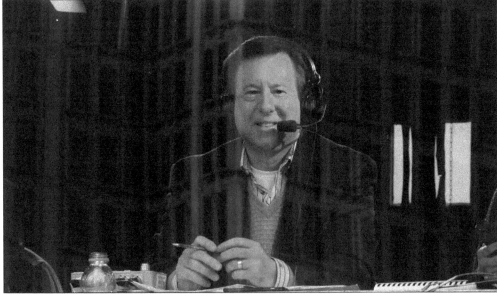

Pictured in 2014 is author Stephen M. Highsmith in the broadcast booth in downtown Philadelphia. Highsmith has been broadcasting the televised parade for more than two decades. He was inducted into the Philadelphia Mummers String Band Association Hall of Fame in 2011 and has been honored by the Philadelphia New Year's Shooters and Mummers Association, the Philadelphia Fancy Division, and various Mummers clubs, including Murray Comic Club, Goodtimers New Year's Association, and the Avalon, Fralinger, and Quaker City String Bands. (PHL17.)

CONTENTS

ACKNOWLEDGMENTS

My thanks go to the men, women, and children of the Philadelphia region who are the Mummers and who carry on America's oldest annual folk parade. They are not only known for their unique celebration on New Year's Day, but also for their Philadelphia Mummery throughout the year. Material for this book comes from my 20-plus years of broadcasting the annual parade, the oral histories of some of its participants, the Mummers Museum, and PHL17-TV.

I would especially like to thank the staff and volunteers at the Mummers Museum, chiefly Mark Montanaro and the Mummers Museum Board of Directors president, George "Rusty" Martz. Thanks are owed to PHL17 senior vice president and general manager Vince Giannini; the staff, including PHL17 chief photographers William Lehan and Tony Romeo; and creative services director Travis Brower. My thanks are also extended to current and past officials of the City of Philadelphia, including mayors and recreation commissioners, and others who have made the parade on the street possible, especially parade directors Leo Dignam and Tom Fox. I appreciate the leadership of the Mummers divisions, including current Comic Division president Richard "Rich" Porco, current String Band Division president Tom Loomis, current Fancy Brigade Division president James Bradley, past and current leaders of the Fancy Division, current Wench Brigades Division president Chalie McKenna, Jessica Porco, Heather Bond, Palma Lucas, and Congressman Bob Brady. Also notable is the involvement and support of Mummery from SugarHouse Casino and of general manager Wendy Hamilton and other corporate citizens, such as PECO, who promote appreciation of all cultures. I also thank Cabrini University for its support of this project, as well as Russ Coleman, Jacob Hart, George Badey, and former broadcast colleagues Ron Goldwyn and Joseph Deighan. And a big thank-you is given to my family, especially my wife, Jayne, for her support and assistance.

The images in this book appear courtesy of individual Mummers, clubs, the Mummers Museum (MM), PHL17-TV (PHL17), the Fancy Brigade Association (FBA), Murray Comic Club (MCC), the String Band Association, and the author's collection (SH). Some Mummers groups call themselves a New Year's Association or a New Year's Brigade and use the initials NYA or NYB. They may be so designated in this book.

INTRODUCTION

Philadelphia Mummers describes Mummery in Philadelphia over the last 50 years, from 1965 to the present. Mummery is about celebrating and is at the core of America's oldest annual folk parade. Mummery comes to life in an outdoor parade and an indoor show for all to see and hear on New Year's Day. Mummers often aim for the "wow" factor, the eye-widening effect the performance will have on the audience. It is an eyeful of fantasy-inspired costumes and huge props and an earful of the new String Band sound, brass bands, or pulsating techno pop. There are satirical, playful, and just silly comic skits, and the people performing are mostly average working people, not professional musicians, dancers, or actors.

Mummery can be traced to words meaning to mask or masquerade or to mock. Being loud, brash, and satirical in their slapstick routines were all characteristics of early Mummery. Philadelphia Mummery started in the late 17th and early 18th centuries as English, Swedish, and German immigrants brought to Philadelphia their traditions of celebrating Christmas week and the New Year. The melting pot of Philadelphia was also influenced by African American culture and by stories of Rome, Egypt, and pre-European America. These celebrations evolved and were strengthened with the addition of newer immigrant populations, including Irish, Italian, and Polish immigrants in the mid-1800s through the early 1900s. As I write this today, discussion of cultural appropriation or coopting of minority influences is in its early stages. Mummers have become engaged in those discussions.

Philadelphia Mummers originally called themselves Shooters and Mummers and in the 1800s, amid a lot of drinking on New Year's Day, guns would be fired into the air. The Mummers Parade, as it is known today, grew out of those neighborhood celebrations that were getting out of hand. To curb them and to attract tourists, the City of Philadelphia and a promoter named Bart McHugh started the first official Mummers Parade in 1901, corralling the various groups onto Broad Street, the lifeblood artery running north and south through Philadelphia. The gunfire is gone from the celebration, but the consuming of alcoholic beverages is not; although, it is not as widespread as its reputation.

For many Mummers fans, especially children and seniors, the Mummers are just plain fun and larger than life, or as Philadelphians say, "Beyoodeeful." For many Mummers, Mummery is a meaningful, active, year-round part of the social and family fabric. Mummer history and practice may coincide, even collide, with the issues of today, but Philadelphia Mummery is also an opportunity for good-minded people to learn from each other; to reflect on freedom of speech and assembly; and to discover tolerance, the meaning of community, and unique artistic expression. It is, at its heart, the joy of celebration and the simple hope for what a new year can bring. This book tries to show that spirit.

New Year's Morning
(A Mummer's Reflection)

We come from docks and factories
From offices and uniform,
With our friends and our families
To be, like the year, reborn.

Dancing, playing, masquerading
Owning the Hall, ruling the Street,
And honoring the ghosts strutting
To the Golden Slipper beat.

Yes, again we come to your door,
Mummers parading fantasy,
Merry makers forever more,
And Philadelphia Free!

—Stephen M. Highsmith

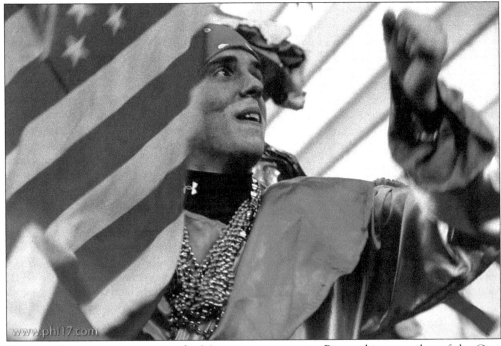

Patriotic themes are common in the Mummers community. Pictured is a member of the Cara Liom New Year's Brigade in 2012. (PHL17.)

One

WHO AND WHAT
IS A MUMMER?

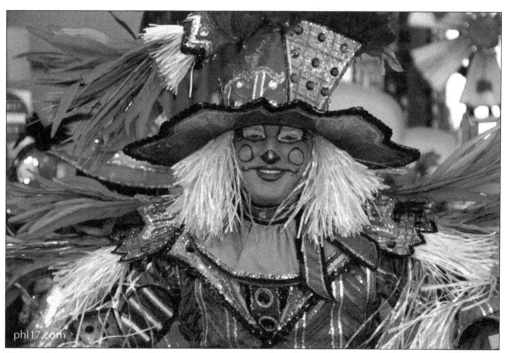

Pictured is a member of Polish American String Band's 2015 barnyard theme, "50 Shades of Hay." A Mummer is a person who participates in Philadelphia's New Year's Day celebration while wearing a unique costume. He or she may be donning a satin Mummer dress with sequins, feathers, mirrors, and/or glitter or some other ornate costuming. They may strut along Broad Street or be part of a well-choreographed, Broadway-like theatrical production lasting 4.5 minutes. Mummers number in the thousands each parade day. (PHL17.)

The String Bands and the Fancy Brigades offer dynamic performances featuring outsized costuming and well-rehearsed choreography. The music is different for each. The String Bands play their own instruments; the Fancy Brigades perform to recorded music. Mummers aim for larger than life, as in this 10-foot-tall South Philadelphia String Band banjo-playing pumpkin. (PHL17.)

The playful parade is an opportunity for friends of all ages to take part in the joy of creating their own art and taking it to the street. The Comic clubs offer an easy access point for individuals, especially children. Here, three kids in the Murray Comic Club (MCC) celebrate New Year's Day together on Broad Street in the "people parade" that is the Philadelphia Mummers Parade. (MCC.)

For some participants, it is a chance to create delicate, live, visual art. At right, Jennifer Amato plays violin in Duffy String Band's "Treble in the Funhouse" in 2016. Jen is a detective with the New Jersey State Police. She is also married to Michael Riddle, president of Aqua String Band. (PHL17.)

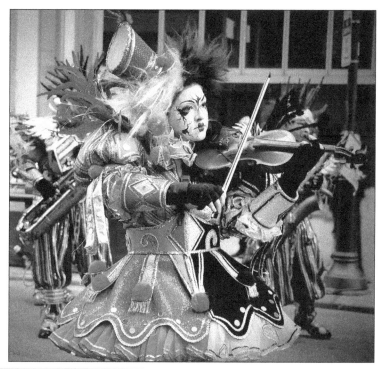

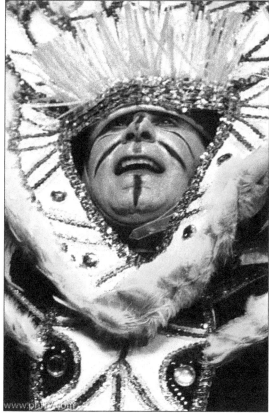

The Mummers main goal is to make a person smile, often through a kaleidoscope of vibrant imagery. Sammy Harris, of Woodland String Band, is pictured at the conclusion of the 2012 performance. (PHL17.)

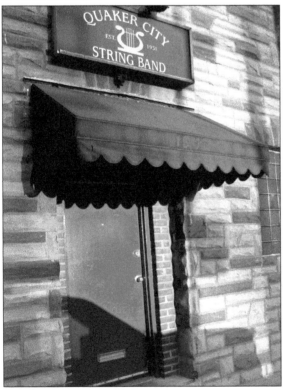

Most Mummers are or have roots in the working class. Above, South Philadelphia String Band's clubhouse sits beside a huge fuel storage tank near a refinery. Mummers usually lived or worked near clubhouses, but in the modern era, suburbanization and the economy would lead to closings, mergers, or in some cases new clubs. Shown at left is the entrance on South Third Street to Quaker City String Band, a member of the Philadelphia Mummers String Band Association. Quaker City String Band has been marching continuously since 1932. (Both, SH.)

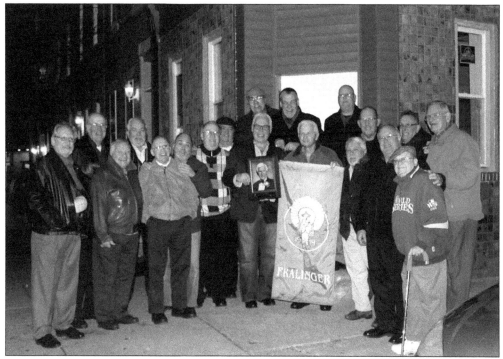

Mummers honor memories and tradition. Above, core members of the modern Fralinger String Band gathered on December 18, 2014, to mark the 100th anniversary of the founding of their band at Second and Sigel Streets in South Philadelphia. A drugstore once sat at that corner. A young Joseph A. Ferko worked at the store, and he and his friends would play outside. Dr. John J. Fralinger, a community leader, physician, and pharmacist ran the store and agreed to sponsor the new String Band in the parade. (Jaimie Bowen, Fralinger String Band.)

Mummers number in the thousands, but for most it is a personal, often family experience, like with this father and son in 1995. The largest Wench Brigade is James Froggy Carr, established in 1971. (MM.)

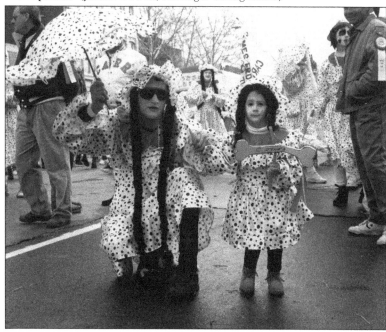

Mummers clubs belong to divisions or categories of presentation. There were three divisions at the beginning of the modern era: Comic, Fancy, and String Band. Later, the Fancy Brigade Division and the Wench Brigade Division were added. Above is a presentation called "Black Magic" by the Charles Klein Fancy Club in 1988. Voodoo and Halloween images are among the common themes in Mummery. (MM.)

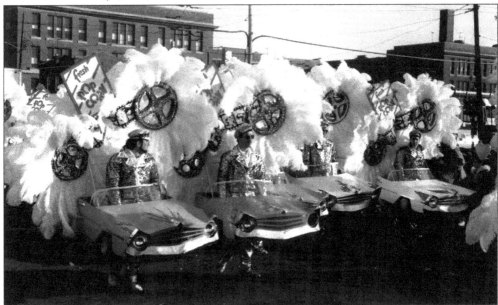

Above, the Jokers NYA, a Fancy Brigade established in 1949, presents "Intermission at the Drive-In" in 1988. (MM.)

Unless performing routines, Mummers strut. The Mummers' strut is generally thought to be inspired by the African American cakewalk of the 1800s. The strut is an exaggerated walk, or modified box step, forward and back, side to side, in which feet are energetically picked up, with heels almost touching one's backside. As this is happening, the strutter is arching his or her back and thrusting up their arms. One hand may hold the edge of one's dress or a partially opened coat. The other hand may pump an umbrella or flash two fingers for Second Street. Pictured is the Riverfront Mummers NYB in 2012. (PHL17.)

The Mummers are mostly white and of European decent. African American participation has been very low since the early 1930s. The Mummers culture was forged through immigration and the experiences of the working class. Some Philadelphians see the Mummers as now having a responsibility, or at least an opportunity, to reach out to African Americans and new immigrants from Latin America. Pictured is the Greater Overbrook String Band; its theme was "Brazilliant." (PHL17.)

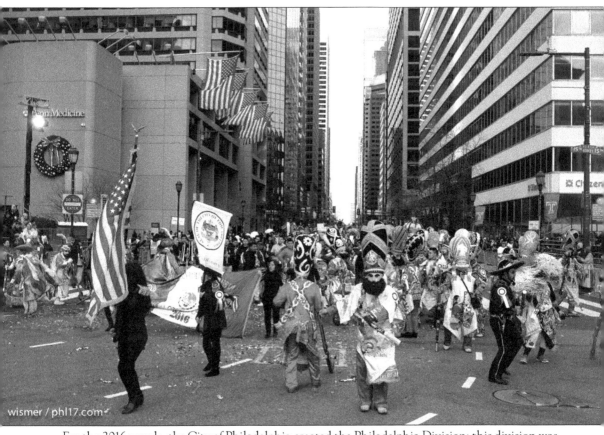

For the 2016 parade, the City of Philadelphia created the Philadelphia Division; this division was established as an attempt to include more Mummers that better reflect the 21st-century makeup of Philadelphia. Joining was the San Mateo Carnavalero Club. Mexican immigrants in Philadelphia conduct a neighborhood parade, which is less than a decade old, to commemorate the historic 1862 Battle of Puebla. The San Mateo Carnavalero Club and other new groups are set to return as part of the regular Mummers Divisions in 2017. (PHL17.)

Pictured above, the Pennsport String Band partakes in a playful pirate theme in the Mummers Parade. All, or nearly all, of the participants in the parade at the beginning of the modern era were male. Mummers groups were fraternal social clubs. Today, more than half of the participants are men, but most of the clubs are open to both genders. Below, the Golden Sunrise Fancy Club performs. (Both, PHL17.)

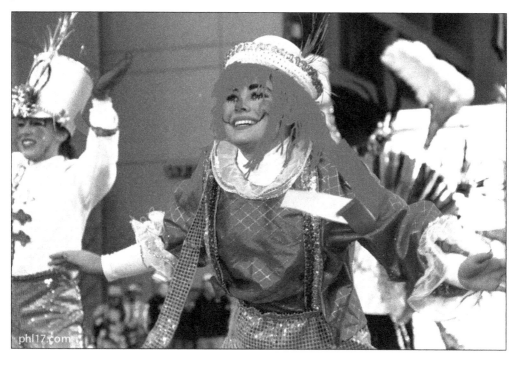

Mummers compete on New Year's Day. The judging is performed in the shadow of Philadelphia City Hall. Winning first prize is significant, carrying with it bragging rights that last a year and even a lifetime. In a long-standing tradition, the winning String Band receives the trophy outside its clubhouse from the previous year's winner. Above, former Woodland String Band captain Dave Anderson Jr. holds the 2012 first prize trophy and celebrates with band members, including club president Tom Loomis, right. It was Woodland's first win since being formed in 1926. (Woodland String Band.)

The Mummer tradition starts early for many Philadelphia Mummers. At left, Bart White, an elementary schoolteacher in Laurel Springs, New Jersey, struts with his daughter Mikaela, who is only a few months old on New Year's Day 2015, as a member of the South Side Shooters NYA in the Goodtimers Comic Club. The memory of strutting on Broad Street lives forever within anyone who has donned "the suit." (PHL17.)

Two

THE COMIC
AND WENCH DIVISIONS

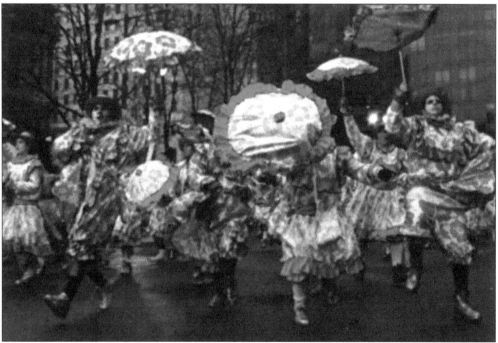

Comics were the first Mummers. They perform in groups or as individuals. Comic categories include best couple, costume, character, brigade, group, juvenile, float, and captain. The Comic Division began centuries ago with men dressing as women, or "wenches." The costume is called a wench suit. Some early Comics dressed in tuxedos or other fancy clothes as "dudes," but after canes were banned to prevent injury, dudes largely disappeared. Some Mummers believe the formal banning of blackface in 1964 also led to the demise of the dude character. Today, Wenches are found in the Comic Division and the Wench Brigade Division. The traditional wench costume includes a satin dress, bloomers, braids, head scarf or bonnet, an umbrella, and golden slippers. Makeup is supposed to fit the brigade's theme. The O'Malley NYA demonstrates the modern "classic" look. (PHL17.)

A Mummer in the Comic Division or Wench Brigades Division wearing a wench suit would not be complete without the accessory of a purse or bag for carrying a "refreshment." This Bryson NYB suit of a barnyard theme includes such an accessory and is on display at the Mummers Museum. (SH.)

The most important element is the golden slipper, a symbol that says what might appear as ordinary or worn is truly of value and beauty. It is taken from the Mummers unofficial anthem "Oh Dem, Golden Slippers," written by James Bland, an African American composer laid to rest in suburban Philadelphia. Mummers occasionally visit his grave site. Most Mummers' slippers are old shoes or work boots, spray-painted gold. Above, members of Goodtimers are pictured in their golden slippers. (PHL17.)

The Comic and Wench Brigade Divisions are the easiest gateways to Mummery. The Sometimes Mummers marched in 2016 with the theme "Welcome to the Tea Party" in the Murray Comic Club. They won first prize in the Group category. (Mark Montanaro.)

Above, Murray president Rich Porco, with a clipboard and bullhorn, walks "backstage" in the late 1970s or early 1980s as his club's performers line up on a side street to begin the parade. Mummers have to start New Year's morning in the pre-dawn hours before the parade, putting on makeup and moving props and floats downtown. Most skits in front of the judges are brief, lasting about two minutes or less. They are usually accompanied by recorded music. (MCC.)

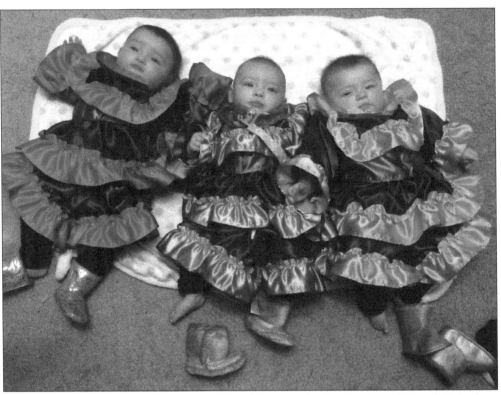

Many Mummers in the Comic and Wench Brigade Divisions start young. Really young. In 2014, Andreas and Courtney Williams of the Holy Rollers NYB took their triplets Diana, Daphne, and Vanessa into the parade as ninja turtles at only a few months of age. They continue to parade. (Courtney Williams.)

Gary Gnu Troendle captures a moment with his daughter Madison and son Keegan. Keegan first went "up the street" at four months old. Troendle's club, Riverfront Mummers NYA, and a half a dozen other clubs have raised funds to pay for Keegan's seven brain-related surgeries. Troendle's grandfather owned the row home that is now Riverfront's clubhouse. Riverfront was founded in 1988. Its longtime captain is Tom Kelhower. (Gary Gnu Troendle.)

In the Comic Division, there are multigenerational Mummer families. One example is Big Mac's Mongoose Mummers of Bellmawr, New Jersey. John Macintyre Jr., who passed away in 2016, began "Mumming" in 1937 with the Bill Morrow String Band, in which his father played. John, a tall man in the purple suit and white hat who became known as Big Mac, moved over to the Comic Division, first with Purul, then Liberty and Murray. His children, grandchildren, and great-grandchildren strutted with him in the parade. (MCC.)

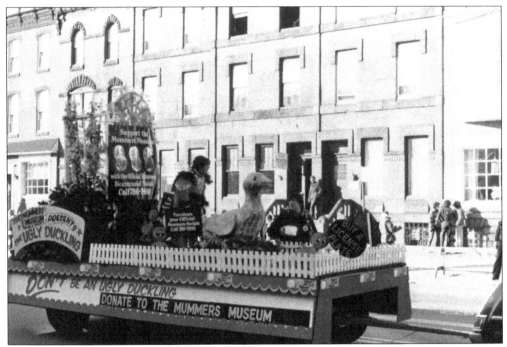

Comics parade within larger Comic Division "mother" clubs, which can carry up to two dozen entries. They include the captain's presentation and Comic Brigades, which are judged at the main judging area known as "A" stand. Additional individuals, couples, and smaller groups are judged at separate "B" and "C" stands. Above, the Hammond Comic Club float in 1976 promoted support of the new Mummers Museum. Philip J. Hammond had marched as a child alongside his dad in the first parade in 1901. His grandfather was also a Mummer. (MM.)

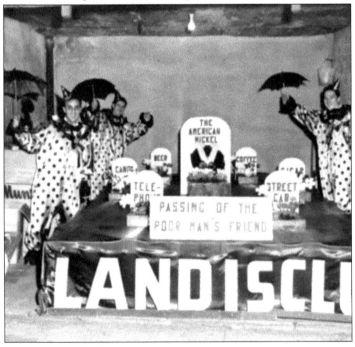

There were several mother clubs in the first half of the modern era. They included Hammond, Landi, Liberty, Murray, Purul, and later the Goodtimers. But by 2009, the number of Comic Division mother clubs had dropped to three: Goodtimers, Landi, and Murray. At left is one of the first images of the Landi Social Club, established in 1950 by baker Nick Landolfi. (Anne Landolfi.)

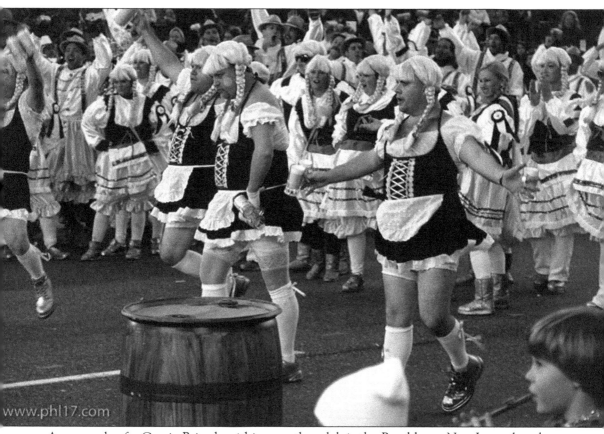

www.phl17.com

An example of a Comic Brigade within a mother club is the Brooklawn, New Jersey–based Two Street Stompers, part of the Goodtimers NYA. The Two Street Stompers first paraded in 1979 and took first prize in 2005, 2009, 2012, and 2015. The Young, Meehan, McLaughlin, and McMullen families lead nearly 200 members onto the street each year. For the club's 2012 theme, "Wenchtoberfest," classic braids were worn along with lederhosen-inspired wench suits. Earlier in the modern era, the length of braids signaled legal drinking age. Shorter braids were given to underage strutters. (PHL17.)

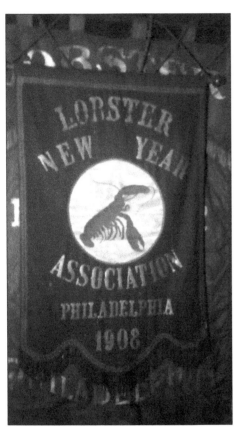

Families, school friends, and other affinity groups populate the Mummers. The Lobster New Year Association began as a social club in 1907 and paraded for the first time in 1908. It was started by five men of Irish and German descent. One of them noted their ruddy complexions and said they look like a bunch of lobsters. The Lobster NYA was born. (SH.)

The Lobster NYA stopped parading in 1969 as its aging membership declined, but it remained a social club. In 2014, revitalized with descendants, the club resumed parading. Today's Lobsters are edgy and creative, and their mantra is "Red Claw Outlaw." It may be in the club's genes. Club historian Mike D'Imperio says that during Prohibition the club served "refreshments," a code word for alcohol. Currently, about half of the parading Lobsters are women. (PHL17.)

In the Comic Division, the Landi and Liberty Clubs are credited with having the first women as captains. Patricia Perla first paraded as captain in 2003 with Landi. Pictured at right, Lori Baals, of Liberty, was the first female captain to win first prize. Baals, from Williamstown, New Jersey, won first prize in 2005 for "Recipe for a Mummer," again in 2006 with "The Days of the Wild, Wild West," and in 2007 with her theme "Hat Trick." (Lori Baals.)

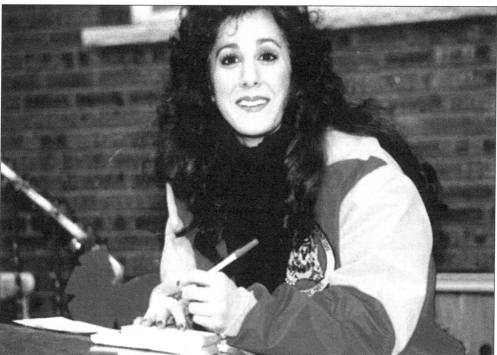

In the late 1990s, Anne Landolfi, pictured, became the first woman to be accepted into the New Year's Shooters and Mummers Hall of Fame. She was the first woman to organize a major club, operating Landi following the death of her father. Steve Melnychuck would later carry on the Landi Club until Chuck Tomasco assumed leadership at the end of the modern era. (Anne Landolfi.)

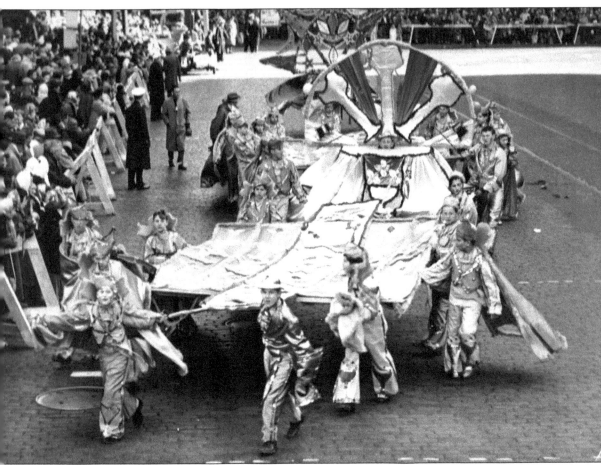

Many changes occurred throughout the Mummers parade over the last half of a century. Some changes affected the Comic and Fancy Divisions more than the other divisions. Above, the Wheeler Fancy Club, performing in 1954, was typical of mid-century Mummery. But when the modern era began in 1965, it started with a major change that had taken place in the previous year concerning a display of Mummery. Blackface, the darkening of the skin with charcoal, lamp black, or other makeup, was now officially disallowed. The use of blackface by white Mummers was a holdover from the minstrelsy period in the United States during the late 1800s through the early 1900s. Though its use had been declining as the nation began changing during the civil rights movement, it was still present in Mummery, and so the ban was imposed. In the decades since the ban, one or a few Mummers out of the thousands of people parading have violated the rule in any given year. (MM.)

Two decades into the modern era, Al Heller, a Comic with the Hammond Comic Club, became a leader for inclusion within the Comic Division and remained so until his death in 2005. Heller and George Hawkins, who had paraded with the all African American O.V. Catto String Band, founded the Goodtimers Comic Club in 1983 and attracted African American drill and dance teams and Asian American entries. The O.V. Catto String Band broke up during the Great Depression, though some members marched in the smaller O.V. Catto Elks Lodge Band with the Hammond New Year's Association until the Goodtimers was formed. Above is a photograph of the O.V. Catto String Band in the late 1920s. (MM.)

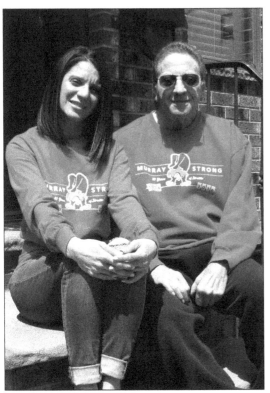

At left, Rich Porco, president of the Murray Comic Club since the mid-1980s, is pictured with his daughter Jessica who is Murray's treasurer. Liberty Comic Club, founded in 1936, won 11 straight first prizes through 1984, but Murray has become the most successful Comic Division mother club, capturing overall first prize a record 18 straight years as of 2016. The club is named after Joseph A. Murray, a beer distributor who sponsored its launch in 1936. The Tyler and Herman families first led Murray, then John Lees, who also helped establish the Mummers Museum, was in charge until Porco took over. (SH.)

Below is Frank Stermel, a museum cofounder and the late father of Murray vice president Mike Stermel. Frank loved being a clown Comic and is featured at the Mummers Museum in still photo sequences showing how to do the strut. Each year, Mike gives out an award, the Mr. Clown trophy, in honor of his father. (SH.)

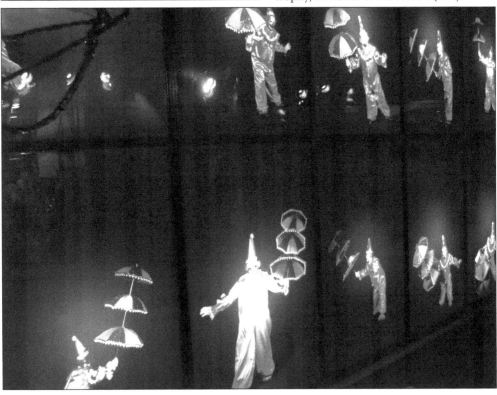

Murray Comic Club captain Dennis Pellegrino is pictured here as a Mummer pirate. Captains are part ringmaster, dancer, and actor on parade day. Among Murray's captains in the modern era are Henry Schultz and Michael Iannelli, who led the Deadenders Comic Club. Pellegrino is the winningest captain, capturing 13 first prizes in 20 years. (MCC.)

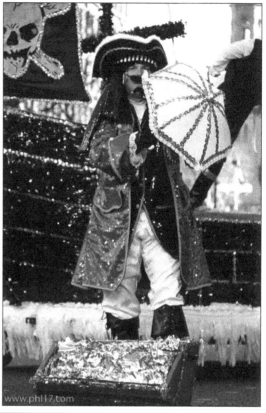

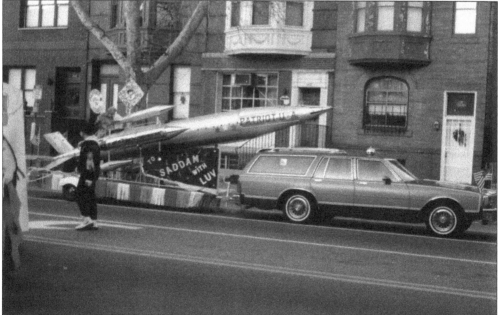

The number of Comic Division floats has diminished over the modern era. Above is the Murray Comic Club float, "To Saddam with Luv," a topical pro-US theme during the Persian Gulf War in 1991. (MM.)

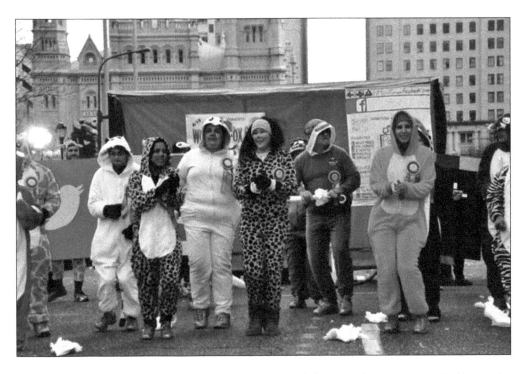

Satire or mocking can be part of Comic Mummery and thus may be controversial. Above, the Venetian Club satirizes cable television news. The Rabble Rousers and the Vaudevillains (seen below) are creative groups targeting topical issues, such as the environment and politics. Vaudevillains performed their theme "Journey to the Center of the Party" in 2014. It was an attack on political failure to fix Philadelphia's crumbling infrastructure. (Both, MCC.)

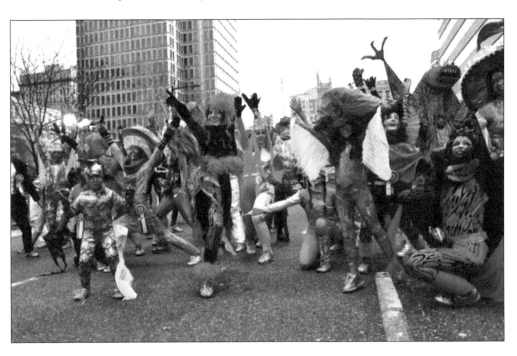

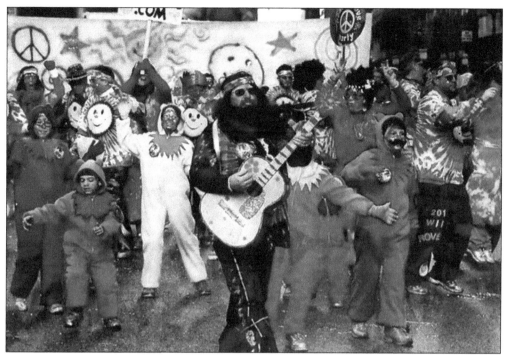

The Wild Rovers NYA was established in 1969. The Rovers beloved captain, Jerry Murray, an attorney, suffered a heart attack in 2009 while performing the club's theme "When Hell Freeezes Over." He passed away in the days that followed. Murray won First Prize Captain twice, including for the performance in which he was stricken. The following year, in 2010, his wife, Joan, and other family members and friends paraded again with a Grateful Dead theme. (MCC.)

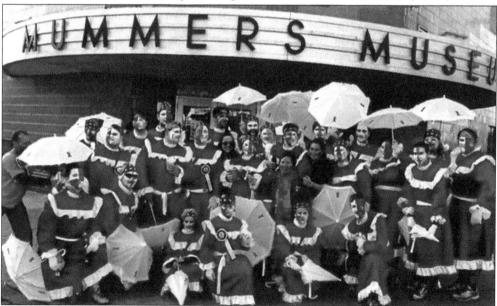

Some clubs are formed in honor of someone who has died, such as the Joey Howlett Jr. Saints or the Spiers Strutters. The Spiers Strutters began marching in 2012 after the sudden passing of young Kevin Spiers, a member of electricians Local No. 351. (MCC.)

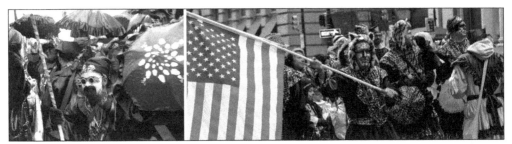

The largest Wench Brigades were spun off into their own division in 2009. Among the largest were the Pirates, led over the years by Joe "Burger" Kirlin, George Stewart, and Steve "Moe" Moscinski, and the Oregon Club (shown above right), a former Fancy club, led by generations of the Paley family. The Wenches may carry a flag, wear a hat with the name of a loved one, or wave a poster, sometimes controversial. (PHL17.)

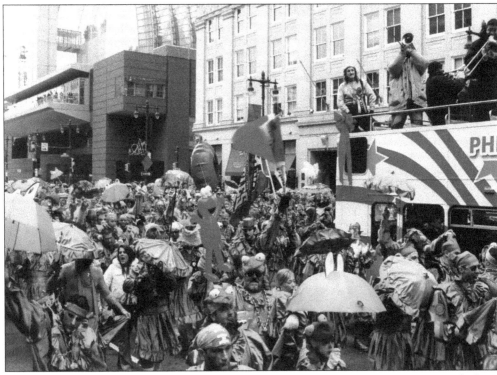

The best-known Wench Brigade is the largest, the James A. "Froggy" Carr NYB, named after a young man nicknamed "Froggy." He was about to join the Army during the Vietnam War but died suddenly after a neighborhood football game in 1970. His friends, many of them graduates of Archbishop Neumann High School, formed the brigade in 1971. They say the club is like its namesake—fun loving and direct with a touch of rebellion. (MM.)

Three

THE FANCY DIVISION

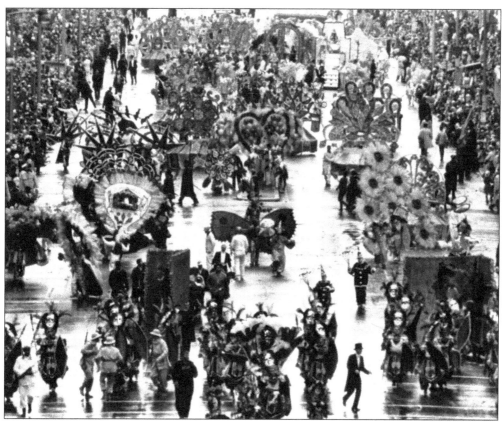

The Fancy Division, or Fancies, evolved from the Comic Division in the late 1880s. In the first half of the 20th century, the Fancies were the most majestic of the Mummers presentations. Some captain's suits could stretch a city block. They would be accompanied by children, called pages, and by strutters in Handsome Trim suits and tuxedos. Above, heading north toward city hall from South Philadelphia, the Charles Klein Fancy Club fills Broad Street as far as the eye can see with presentations. (MM.)

Part of a Fancy club captain's cape is on display at the Mummers Museum. These capes were usually sewn and embroidered by Mummers in basements and warehouses. By the 1960s, large captain's capes were mostly gone from the parade. Below, in this image of the Charles Klein Fancy Club in 1970, one panel of a cape is used on the front and the back of the theme "The Whole World Loves a Clown." Klein captured second prize. (Left, SH; below, Matthew Leighton III.)

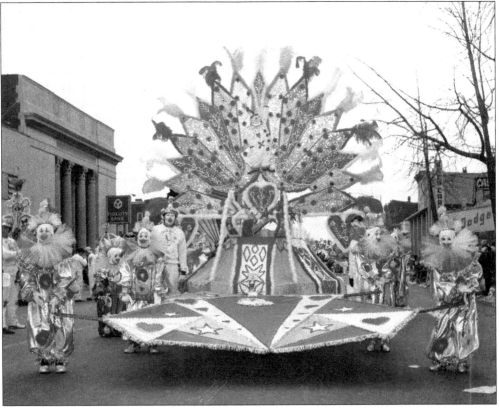

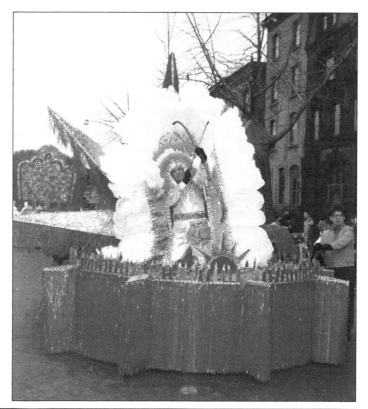

In 1970, Ralph Tursi, of the Clevemore Fancy Brigade, carried a suit called "Flaming Arrow" up the street for the Golden Sunrise Fancy Club. That same year, Chick Veasey won First Prize Handsome Costume for the Oregon Fancy Club with his theme "Salute to the Academy Awards." Later, Golden Sunrise created the patriotic shuttle float seen below. (Right, MM; below, Palma and John Lucas.)

The Fancy Division, also known as the "pretty suit" division, featured "frame suits" containing a yoke, spreaders, and legs constructed with metal pipes, wood, wire, and later PVC. Fabric, glitter, mirrors, and feathers would be laid over the frame. The Mummer could pull it or be in the middle, "wearing" the suit. These suits could be very heavy. Above is a suit built in 1976 and refurbished in 1990 to honor some of the great Fancy Mummers, including Robert Meimbresse, former captain of Hog Island NYA and former president of the Mummers Museum. Next to it is a car prop used in a 2012 Durning String Band performance called "We're Wheelie Motorvated." (SH.)

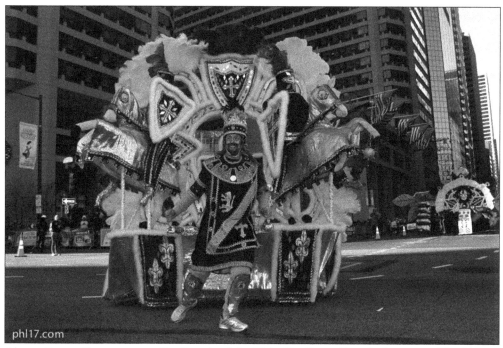

Above, Bryan Chevy presents "In Search of the Holy Grail" as a King Jockey entry. The Fancies have categories, and King Jockey requires a horse-related theme. The suits fit categories unique to the division. Another category is King Clown, which must have a clown or circus motif. (PHL17.)

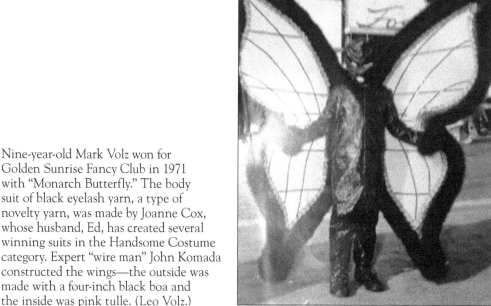

Nine-year-old Mark Volz won for Golden Sunrise Fancy Club in 1971 with "Monarch Butterfly." The body suit of black eyelash yarn, a type of novelty yarn, was made by Joanne Cox, whose husband, Ed, has created several winning suits in the Handsome Costume category. Expert "wire man" John Komada constructed the wings—the outside was made with a four-inch black boa and the inside was pink tulle. (Leo Volz.)

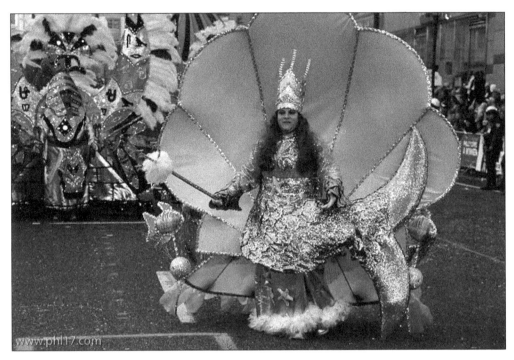

Margie McLean Medeiros's mermaid presentation in Hog Island NYA is pictured above. Fancy members can perform individually; in the larger captain's presentations; or as part of a Fancy Trio, in which costumes are identical. Members can also be involved with gigantic props or floats, such as this 1989 Oregon NYA entry below called "Twilight Zone." (Both, MM.)

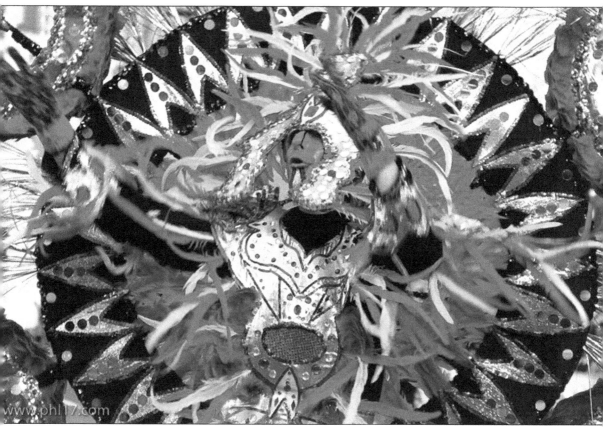

The category of Handsome Costume is often the most startling, vibrant, and energetic. Suits display hundreds of feathers and likely a back piece. Local WMMR radio disc jockey and Mummer Jacky Bam Bam won first prize in 2010 with "Firestarter," pictured above, and again in 2014 for the "The Forgotten Warlock." Jacky paraded for several years with the Fancies and then joined Clevemore Fancy Brigade in 2015. The suits were created by John and Palma Lucas. (PHL17.)

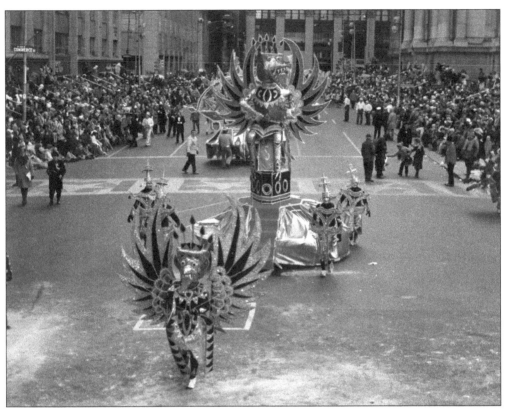

John Lucas was captain of Golden Sunrise from 1972 through 1990 and again from 1994 to 1997. He would make a farewell cameo captain's appearance in 2010. Lucas is among the best-known makers of Fancy back pieces, often working in his basement. Palma Lucas would make the body suit in the presentation. The Lucas suits might weigh 200 to 300 pounds or more. (Above, John Lucas; below, SH.)

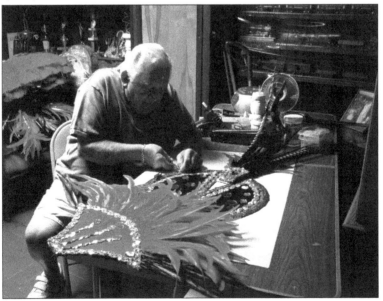

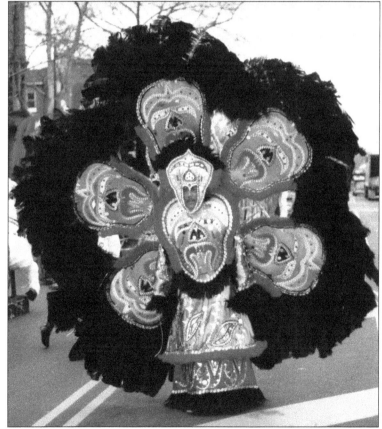

Above, a Hog Island NYA entry is moving up the parade route in 2005. Among Hog Island's list of captains were Ken "Mr. Detail" Medeiros, Joe Keyser, and Dr. Mark Wray. Golden Sunrise's second-longest-serving captain was Matt Glovacz. He captained the club from 1998 to 2013 and again in 2015. At right is a 1988 Golden Sunrise Handsome Costume entry called "Mystic Prince." (Both, MM.)

The Mummers Museum was established in 1976 in South Philadelphia. Above, at center, Palma Lucas, the matriarch of Golden Sunrise, would not only sew and glue suits, but also serve as director of the museum into the early 21st century. (PHL17.)

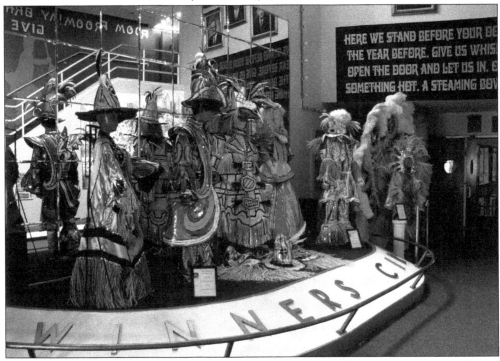

The Mummers Museum is largely run by volunteers. Under the leadership of museum board president George "Rusty" Martz, the museum remains a common meeting place for Mummers. Its Winners Circle showcases and its artifacts educate about the Mummer tradition. (SH.)

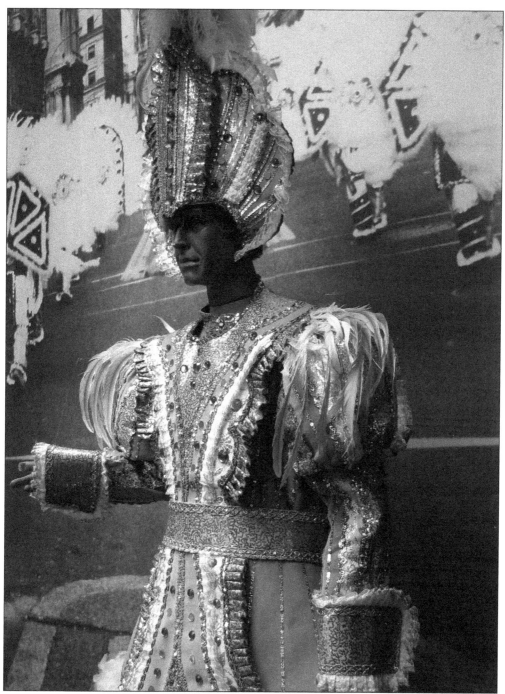

In the museum's Broad Street gallery, suits throughout the decades are on display, such as the one wore by Greater Overbrook captain Jim Driadon in 2010, his 60th parade. The museum sits at South Second Street and Washington Avenue, at the north end of Mummers Row. Many Mummers clubs and homes are along a stretch of South Second and South Third Streets or are on nearby streets. (SH.)

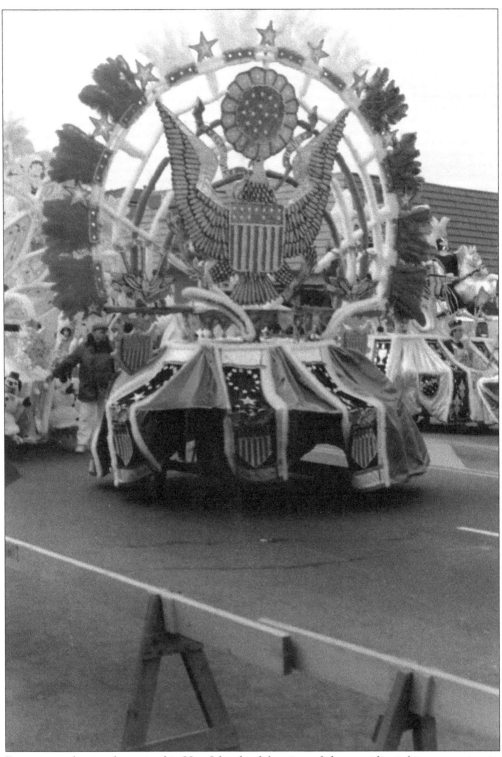

Fancies can be timely, as in this Hog Island celebration of the presidential inauguration in 1993. (MM.)

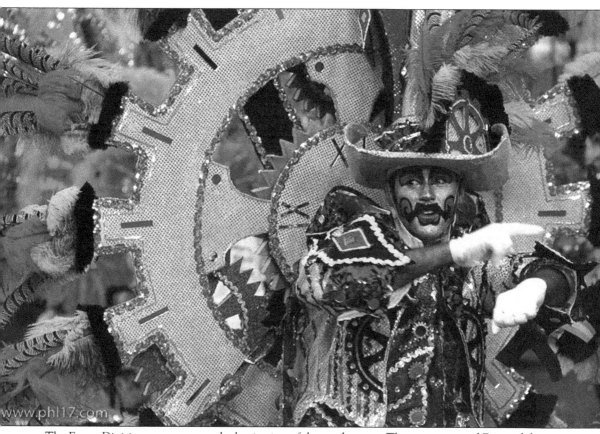

The Fancy Division was strong at the beginning of the modern era. There were several Fancy clubs and each contained at least five big brigades. However, over the era, most of the clubs dissolved or moved to other divisions because of cost and fewer members. Increasingly, some younger members, such as former first prize winner Jozef Jozefowski, headed to the energetic Fancy Brigades Division. By 2016, the number of Fancy clubs had diminished to just one, Golden Sunrise NYA. Above is a Jozefowski Handsome Costume. (PHL17.)

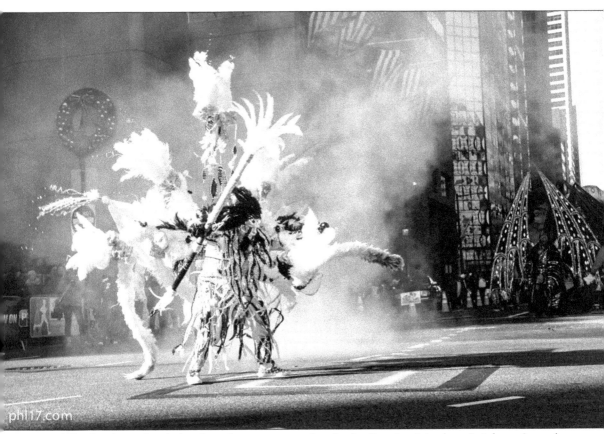

The Leighton family has long been associated with the Fancies. Matthew Leighton Jr. and his brother Bill were among the Leightons to strut in the parade over several decades. Above, Matthew Leighton III, carrying on from his father, won first prize in 2015 in Golden Sunrise with his presentation "Ghost Dance." This Handsome Costume entry perfectly illustrates the visual and thematic styling that still influences the rest of Mummery. (PHL17.)

Four

THE STRING
BAND DIVISION

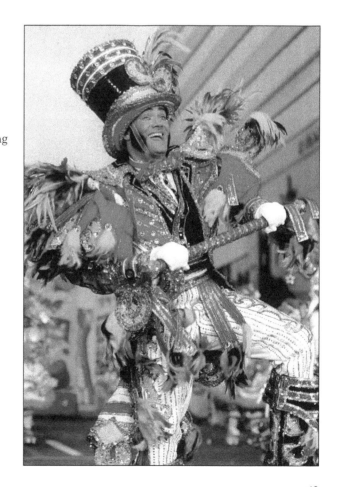

The Philadelphia Mummers String Bands became the single most popular division of the Mummers in the modern era. They each feature 40 to 70 costumed performers, most playing instruments. The String Band produces a unique sound. No brass instruments are allowed, only woodwind, percussion, and strings. In 1965, there were 20 string bands parading. That number grew to 27 in 1985 and 1986, and then began to decline, leveling off to about 17 bands between 2001 and 2016. Avalon String Band captain Jack Hee (right) won Second Prize Captain in 2013 for his performance in Avalon's circus theme "Under the Big Top." (Jack Hee.)

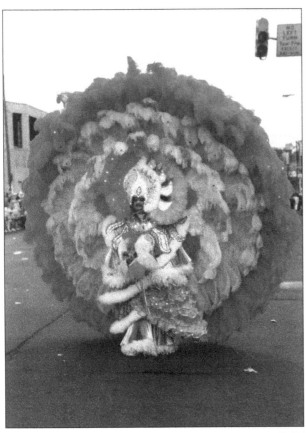

Garden State String Band captain and cofounder Frank Anello, pictured at left in 1988, was a barber in Gloucester City, New Jersey, and a veteran of World War II. The World War II and Korean War generations fueled the huge growth of String Bands, along with suburbanization. But as those generations retired, membership in the String Bands declined, until leveling off over the last decade. As some Mummers left Philadelphia during the 1960s and into the 1980s, they moved to Camden and Gloucester Counties in New Jersey and to Delaware and Bucks Counties in Pennsylvania. There they found plenty of friends willing to form bands closer to where they lived. Pictured below is Berlin String Band's "King's for a Day" in 1995. Elvis has always been popular with Mummers. (Both, MM.)

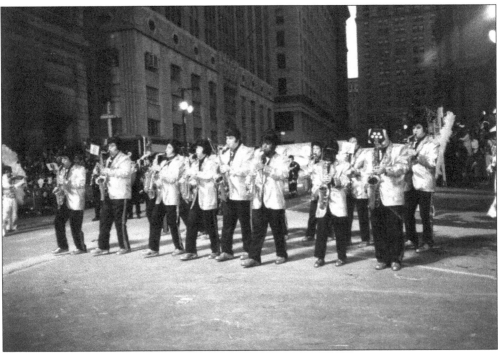

Tenor, alto, and bass saxophones began dominating the String Band sound during the modern era. But the banjo, drums, bass fiddle, accordion, and glockenspiel, or bells, continue to be important. One of the best-known bells players was Joseph Trinacria, pictured at right in 2002, of Bensalem, Bucks County, Pennsylvania. He played the glockenspiel during more than 50 years of Mummery and was captain of Uptown String Band, which took third prize in 1980. (Joseph Trinacria.)

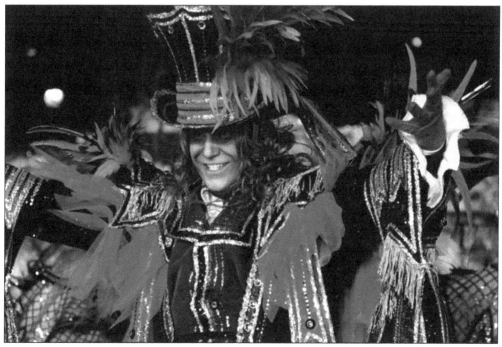

Captains performances are judged. Here, the Fralinger String Band and its 2013 first prize theme "Fralinger . . . Back from the Dead" is shown. Captain Thomas D'Amore won First Prize Captain in 2010, 2012, and 2013. (PHL17.)

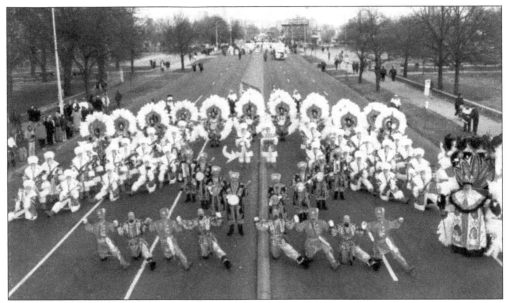

The Joseph A. Ferko String Band has the most first prizes (20) since the 1920s, followed by Quaker City String Band (19) and Fralinger String Band (18). But Quaker City and Fralinger have achieved more wins in the modern era. Above, Quaker City's 1999 first prize theme "Reflections of Old Moscow" is pictured. The win was the first of four in a row for Quaker. The String Bands are judged on music, costuming, performance, and overall production. Each band can spend tens of thousands of dollars to well over $100,000 to produce its performance on New Year's Day. (QCSB.)

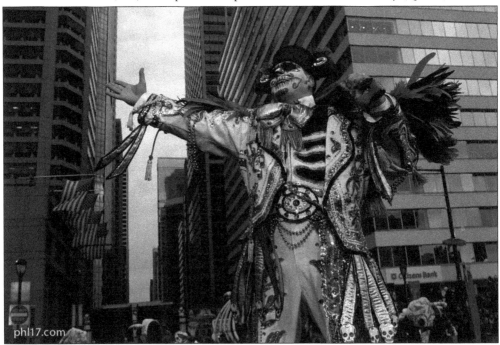

In 2016, South Philadelphia String Band earned one of its three first prizes since the mid-1960s with the theme "Dia de los Muertos." Captain Denny Palandro, a longtime leader in the String Band Association, finished his ninth year as captain with the club's victory. (PHL17.)

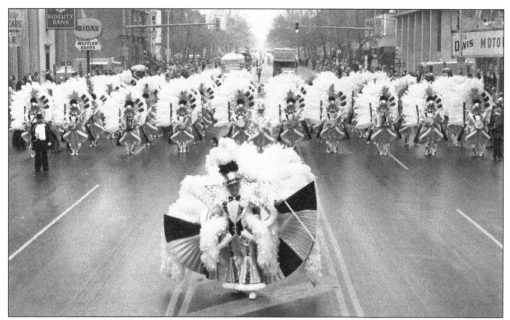

Above, the Fralinger String Band and captain Bill Bowen Sr. showcase "Move Over Broadway" in 1981. Fralinger String Band (pronounced with a soft "g") was formed in 1914 and to date has the most first prizes (17) of the modern era. In the mid-1960s, John J. Fralinger Jr., son of the founding sponsor, had been leading the band, but in 1974, a core group of members, including Bill Bowen Sr. and his son, would lead a transformation of Fralinger that yielded wins in 1983, 1984, and 1987 and then an unprecedented eight wins in a row from 2003 to 2010. Fralinger won first prize in 2015 with the theme "The Machine," seen below. A banjo player performs on a spinning cog. No motorized props are allowed in Mummery. (Above, MM; below, PHL17.)

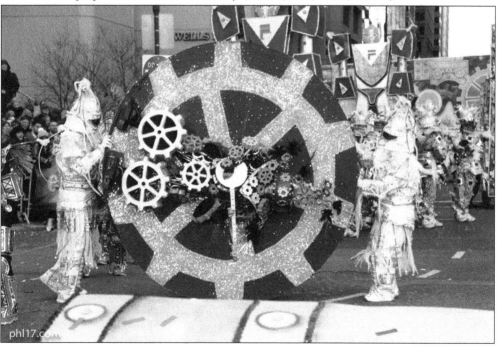

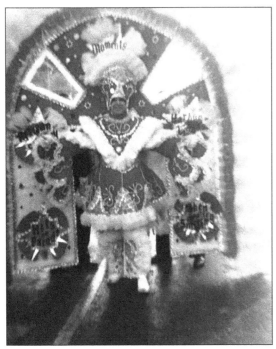

Polish American, Hegeman, and South Philadelphia are among other leading String Bands. South Philadelphia captain James Donaghy won First Prize Captain in 1958, 1959, and 1960 and remained a force as the modern era began, winning in 1966 and again in 1980. The band has won three times in the modern era. Pictured here is Donaghy in "Moments to Remember" in 1971. (Don Morrissey.)

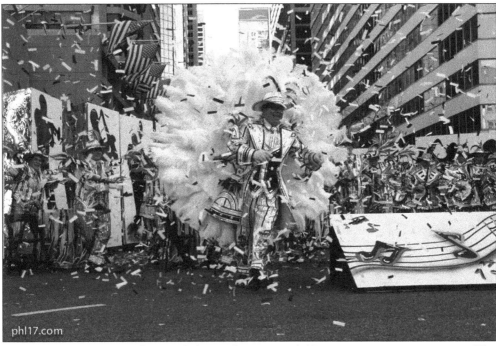

Designer Russ Fama says that until the modern era, a club's movements were geometric. The innovation of dance raised not only the level of visual entertainment in the Mummers, but also the need for functionality in costuming. For String Bands, this means more skill and rehearsal and less restrictive costuming, makeup, and masks. Above, Aqua String Band captain Ken Maminski, a Philadelphia police officer, dances through an always moving band in 2016. He followed another active captain, Ron Iannacone. (PHL17.)

The modern era would usher in significant changes in music, dance, design, and costuming. As the era progressed, more clubs sought out the talents of designers and costumers, usually connected to Philadelphia Mummery. At right, a young Robert Finnigan performed in the parade before dedicating his life to design. He has since been connected to nearly 50 first prizes in the String Bands and Fancy Brigades since the 1960s. (Robert Finnigan.)

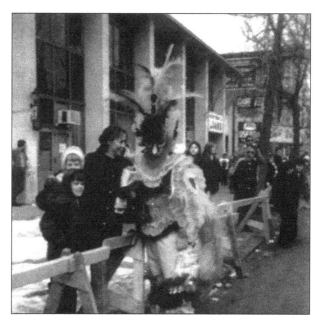

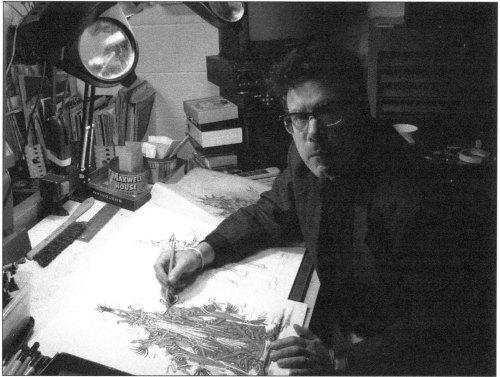

Designer Russ Fama, pictured in his Delaware County studio, played drums in South Philadelphia String Band in the mid-1970s. He acknowledges the works of costumers such as Van Horn and Son Theatrical Costuming, Carl and Mary Braun, and Dave Moscinski, with whom he worked, having learned a lot about fabrications from them. He says costumer Jimmy May brought a lot of glam to Mummery in the 1970s. As the era closes, a new generation of designers and costumers is beginning. (SH.)

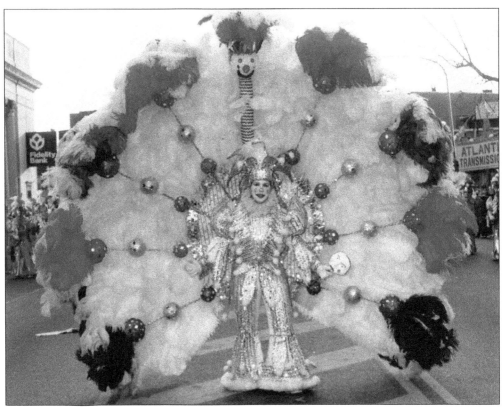

Designers Russ Fama and Robert Finnigan say a major development was the concept of the pit band. This group of musicians, usually saxophonists, is given a different costume from the rest of the band, is kept packed in the center, and is allowed to do a separate dance routine. Finnigan says it may have begun in 1962 with Quaker's City's McNamara's Band, but it took hold with Fralinger's 1984 theme "Jokers are Wild." The captain (above) still had a large back piece and lots of feathers, however, the sax players dressed and moved separately. The pit band became the norm. Note the different costuming in the center of Fralinger a decade later in 1994. (Above, Jaimie Bowen; below, Fralinger String Band.)

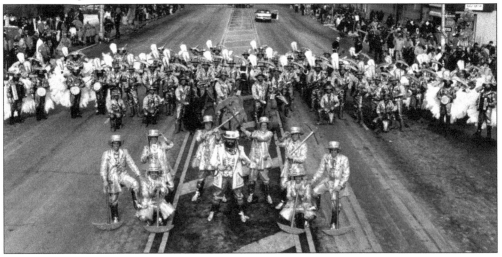

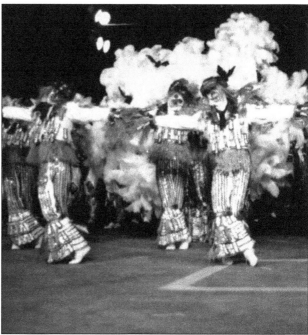

Choreographer Dennis Quaile has charted the movements in more than 200 Mummer themes and is in both the Philadelphia Mummers String Band Association and Fancy Brigade Halls of Fame. He performed with Greater Overbook as a teenager and later joined Quaker City String Band, becoming its choreographer in 1980. He danced in and choreographed the band's first prize 1985 theme "The Scarecrows Hay Day." (Above left, Dennis Quaile; above right, John Keane.)

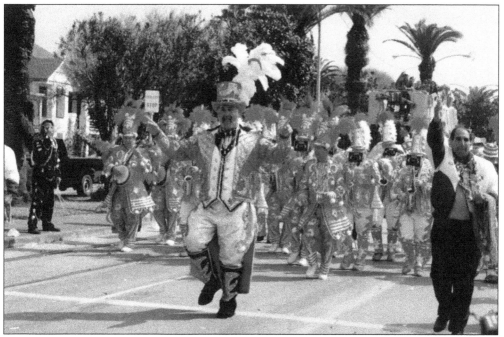

The mid-1980s also saw the start of Quaker City String Band's annual trip to Galveston, Texas, to participate in Galveston's Mardi Gras parade. (QCSB.)

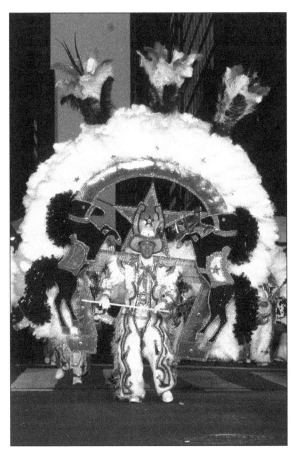

Dennis Quaile believes dancing in the String Bands may have first appeared with Quaker City and its "Gypsy Tambourines" theme in 1963, but he says Harrowgate String Band won first prize two years in a row in the mid-1970s with a focus on choreography, a more Broadway-like performance, making dancing a mainstay. Quaile says the desire for movement required change. This back piece worn by Ferko captain Phil Rotindo in 2002 had become a rarity by the close of the modern era. (Phil Rotindo.)

James Good, seen below, was a dancing first prize winning captain in 2015. Quaker City String Band has had only four captains since 1931: Ray Endriss, Robert Shannon Jr., Charlie Roetz, and James Good. "Scraps," the big dog in the 2015 performance, is a great example of the large "wow" factor props that come center stage near the end of modern-era String Band performances. (PHL17.)

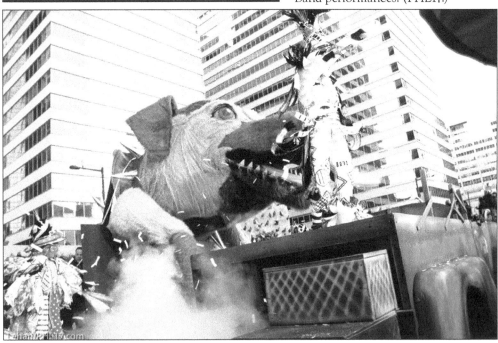

Choreographer Dana Lynch Theil, seen above with Fralinger captain Scott Wray, runs the Pennsport School of Dance along Mummers Row. She has worked with half a dozen String Bands and as many Fancy Brigades, including the newest, the Spartans. Theil says a big change in the last three decades has been the move from "specials," five to eight dancers, to everyone dancing. (Dana Lynch Theil.)

Yvonne and Al delBuono are pictured in their South Philadelphia costume shop. The delBuonos say early Mummery used tailors, but design-savvy costumers became popular. Al and Yvonne work with as many as nine clubs a year and have captured 26 first prizes in the last 28 years of the modern era. They say a band would have one costume style in the 1960s, but now there may be eight different designs within one band. The trend has been away from feathers and toward more durable, flexible fabrics and inlays, and glass mirrors have been replaced by novelty glass. (SH.)

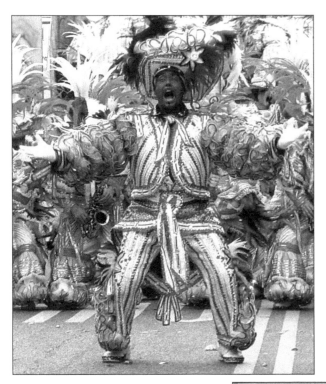

Fralinger captain Bill Bowen Jr. has more captain's first prizes (10) than any other String Band captain. In his 27 years as captain, he finished first, second, or third 20 times. (Jaimie Bowen.)

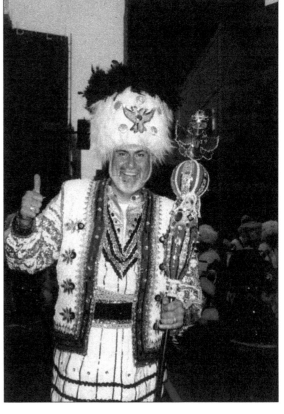

Quaker City captain Robert "Bob" Shannon earned seven first prizes in his 37 years as captain from 1971 through 2008. He was likely the most popular Mummer of his time and its best ambassador. His 6-foot, 10-inch frame; broad smile; and grand gestures made him a hit with fans. (Bob Shannon.)

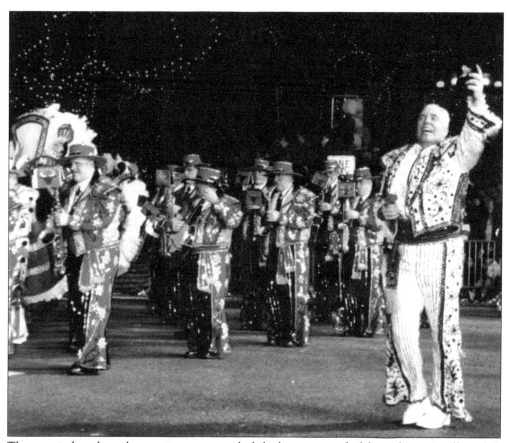

The captain has always been a ringmaster, and while that command of the audience is still needed, as the decades unfolded, dancing, costume changes, and acting became important, too. Above, Bill Bowen Jr. is finishing "Fralinger Reigns in Spain" in 2000. (Jaimie Bowen.)

As design, costuming, props and movement evolved, so too did Mummers string band music. The unique sound remains but newer music has mixed with traditional. The difficulty of the scores has skyrocketed, and all while the musicians are dancing. Among the most influential of the modern-era music directors were Herb Smith, Jim Fox Jr., Ray Mallach, Fran Kerr, John Wernega, Fran Rothwein, Chris Farr, and Don Morrissey. (SH.)

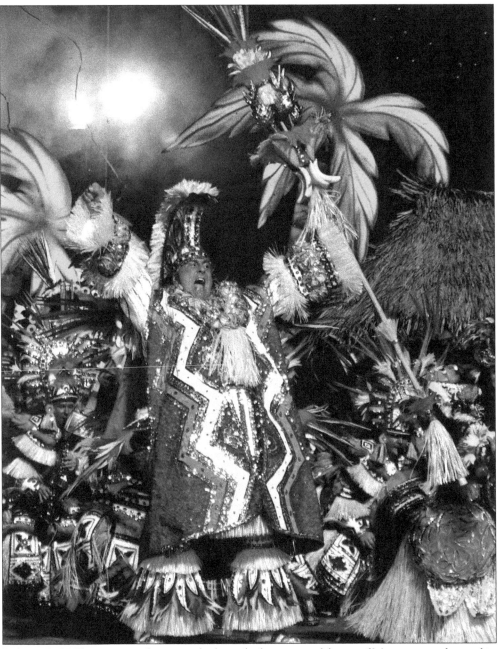

Robert "Bob" Shannon cared very much about the heritage and future of Mummery and served in leadership positions, including as president of the New Year's Shooters and Mummers Association. His father was a member of Quaker City. Above, Shannon is seen in 2008 in his final New Year's Day performance. (QCSB.)

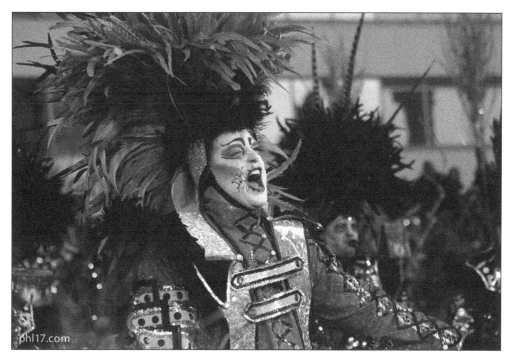

One of the most innovative bands in the last half of the modern era has been Hegeman String Band. Hegeman (pronounced with a hard "g") was established in 1920 and has won first prize 10 times, with three of those wins in the modern era, in 1971, 1992, and 1995. John Baron became captain of Hegeman in 2001. Below, "Hegeman's Household Havoc" finished second in 2014. It was the first String Band to use video as part of the performance. (Both, PHL17.)

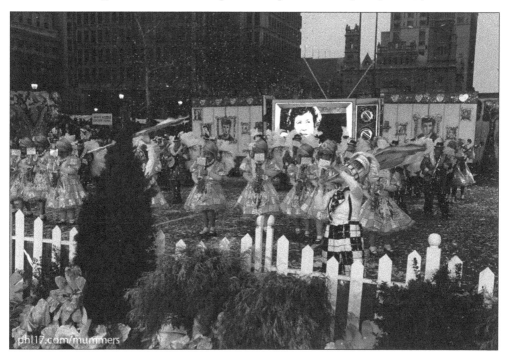

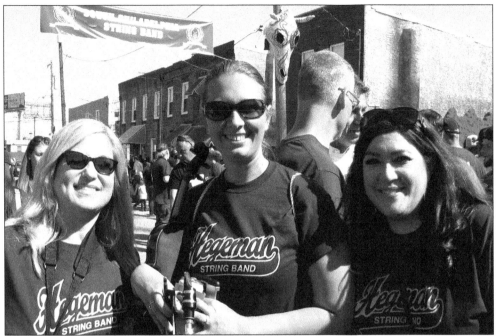

Above, members of Hegeman, a String Band with equal numbers of men and women, are shown. Women becoming parading members was a major development of the modern era. Philadelphia Mummery had been, for most of its existence, a male celebration, but women began officially playing in String Bands in the mid- to late 1970s. A pioneer was Patricia Kerrigan, who with three other women, joined Duffy String Band in 1978. Kerrigan rose to music director of Duffy from 1981 to 1984 and later played with the Juniata and Trilby String Bands before retiring in the late 1990s. Kerrigan and her daughter Barbara became the first multigenerational female-playing members in the String Band Association. They are seen below performing Juniata's theme "Everything's Coming up Roses" in 1987. (Above, SH; below, Barbara Kerrigan Day.)

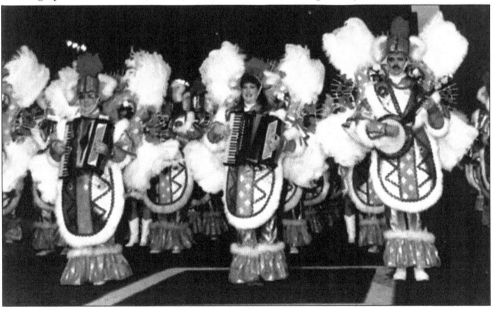

Among other trailblazers are Duffy String Band members Peg Rullo (far left) and Cheryl Crowe (second from left), who in 2011 would be the first women admitted into the Philadelphia Mummers String Band Association Hall of Fame. The women are seen above at rehearsal with Hall of Famers Charlie Kochensky and Ted Kudrick (third and fourth from left, respectively) and other band members. (SH.)

Kelly Marie Mahon is perhaps the best-known female captain of the modern era and the longest-serving one. Mahon led Irish American in 2001 with its theme "Bloomin' Mummers." She remained captain through the 2010 parade, the last year Irish American participated. Pioneering women among String Band captains include Dorothy Pleis of South Jersey String Band in 1982, Mary Shaw of South Jersey in 1989 and South Jersey/Palmyra in 1991, and Fern Dorfman of Berlin String Band in 1994. (Kelly Marie Mahon.)

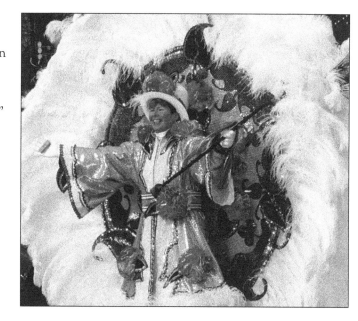

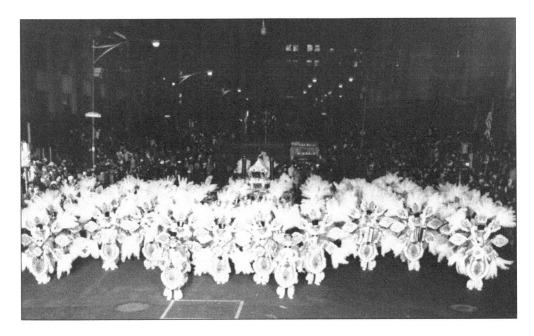

Mergers became common in the late 1980s and early 1990s. The Durning and Garden State String Bands merged in 1988. Pictured above is Garden State's "A Rose Parade Featuring Riverboat Melodies" in 1976. South Jersey and Palmyra merged in 1989. A few years later, the new Palmyra would merge again, with Original Trilby String Band (below). Trilby, established in the late 1890s, was led by the Kaminski family at the closing years of the modern era. (Above, MM; below, PHL17.)

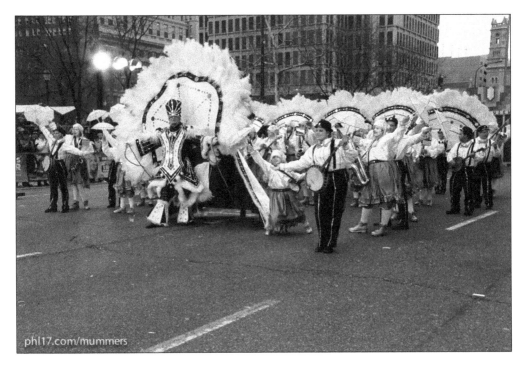

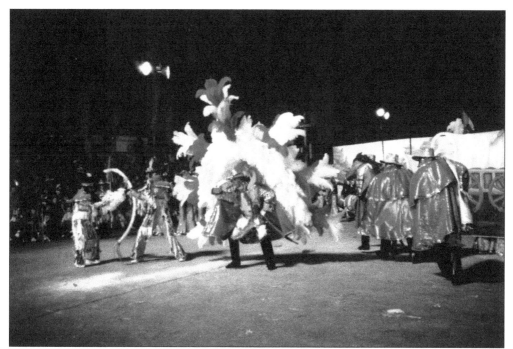

The Joseph A. Ferko String Band can boast of popular, influential captains. Its modern history includes the very popular Joe Blass, who won First Prize Captain in 1974 while the band he led won in 1969 and 1974, and Bill Speziale, seen above in 1995, one of the early dancing captains. He led the band in 20 parades from 1980 to 1999. Speziale won First Prize Captain in 1982, 1985, and 1988, and his band won five times, including three times in a row from 1996 to 1998. (MM.)

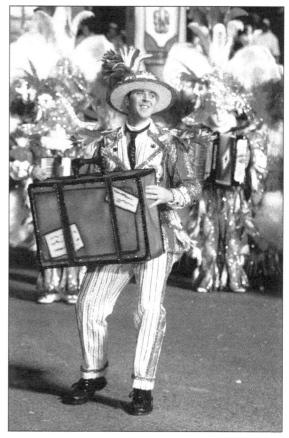

Pictured at right is Ferko String Band captain Phil Rotindo, the "Fred Astaire" of captains in 2007 with the theme "Under Paris Skies." Rotindo captained Ferko from 2000 to 2008, winning the captain's first prize in 2003 and 2007. He was followed by longtime club president and String Band Association officer Anthony Celenza. In 2016, former Fralinger captain Thomas D'Amore was elected to succeed Celenza as captain. (Phil Rotindo.)

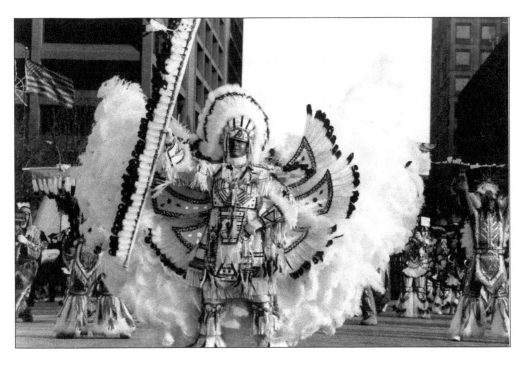

Greater Kensington String Band (GKSB) captain Scott Moyer won First Prize Captain in 2001. His uncle Ron Moyer won the captain's prize twice, in 1976 and 1981. GKSB won the club prize in 1988, with one of the great pun themes, "Go for Baroque." Several Moyers have been in the band. Scott's son Jeff Moyer had his first parade as captain in 2016, at 21, the youngest captain in GKSB's history. (Both, GKSB.)

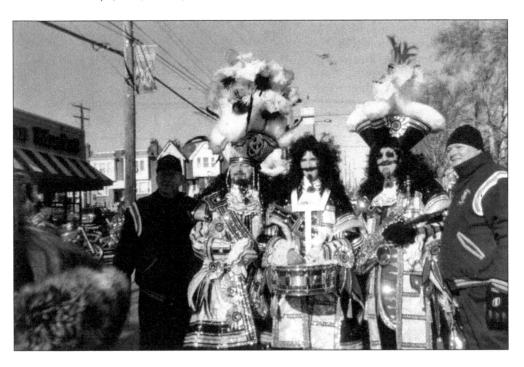

Pictured at right is
Charlie Muraresku
with children Donna
(left) and Rick
(right). There has
been a Muraresku
family member in
the South Jersey–
based Durning
String Band since
1942. The band
first paraded in
1936 and was later
renamed the James
V. Durning String
Band in honor
of the founder's
son, who became
missing in action
in World War II.
Below, captain Jerry
LaRosa Jr. leads the
band in "Durning's
Boot Camp Boogie"
in 2006. (Right,
Rick Muraresku;
below, MM.)

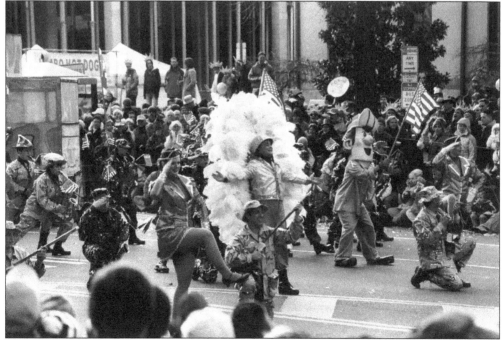

The Broomall String Band is one of the few remaining family-controlled bands. There have been five generations of Broomalls who have paraded, starting with Peter A. Broomall and his sons James and Edward. His grandson Peter J. Broomall Sr. is a reverend with the United Methodist Church in Malaga, New Jersey, and retired as captain in 2016. Peter J. Broomall's son P.J. and grandsons Mason and Kaden have also marched. Broomall String Band finished fourth in 1974 with captain James Broomall and their theme "The Sound of Music," seen below. (Both, Broomall family.)

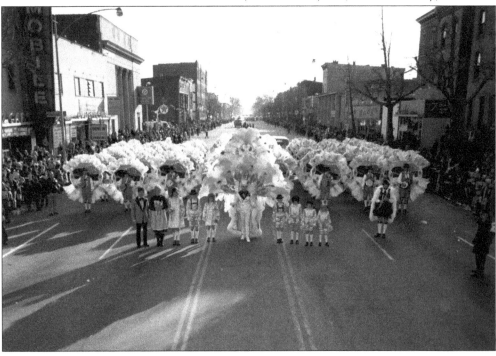

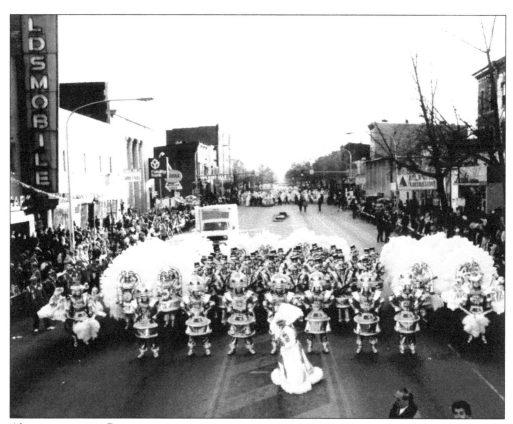

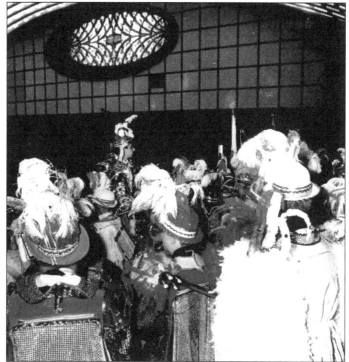

Above are captain Ray Danielewicz and Polish American String Band's 1986 first prize theme, "Dr. Hi-Tech and His Robot Ramble." Four of Polish American String Band's 11 first prizes have come in the modern era, including in 1990. Along with Walter Kropp, Phil Lipiecki, the Danielewicz and Magenta families have been among the leaders of Polish American. Mark Danielewicz followed his father as captain and won first prize in 2011. Nick Magenta is captain at the close of the era. His father, Stan, was a revered captain. The band played for Pope John Paul II in 1998 at the Vatican. (Both, Polish American String Band.)

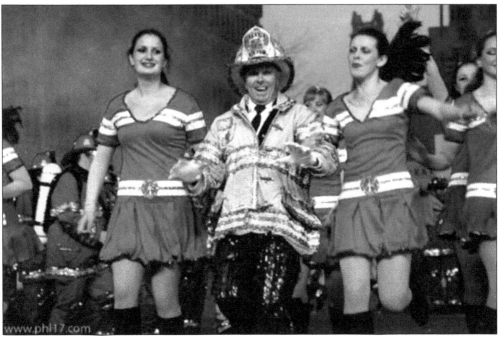

In the 1800s, dock workers organized into Mummers groups often around the cargo they handled. Mummers are often tied to other affinity groups like unions, such as IBEW Local 98, the Sheet Metal Workers, or the Longshoremen, and other groups, such as police officers and firefighters. Upper Darby Township deputy chief John Hicks (above) and John McDermott (below), a member of the Philadelphia Fire Department for 30 years, each led Greater Overbrook String Band. (Above PHL17; below, Karen McDermott Specht.)

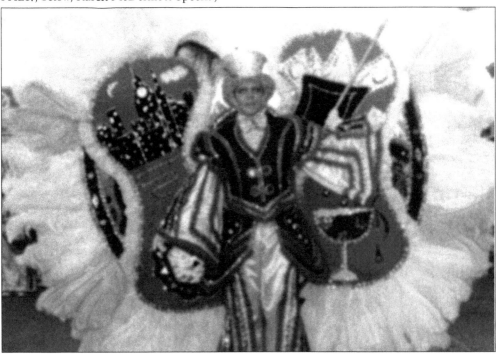

Cigarettes influenced at least one band name. Avalon started as the 12th Ward String Band in the 1930s but renamed itself after a popular cigarette brand in 1944. One of Avalon's better-known members is Judge Jacob "Jake" Hart, a US federal magistrate for eastern Pennsylvania and a Mummers parade television commentator since 2003. It was Durning's 1989 theme, "Custard's Last Stand," that inspired Jake to annually award the Custard's Last Stand Award to the band with the "punniest" theme. (Jacob Hart.)

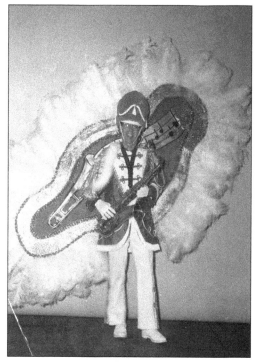

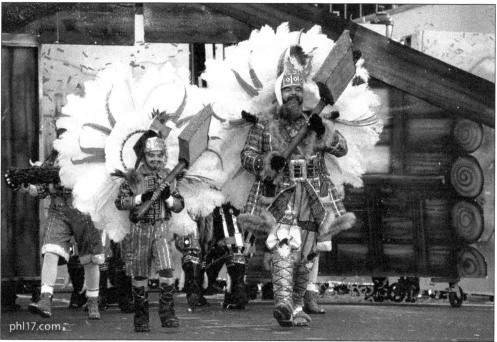

Duffy String Band won for the lumberjack theme "Log-A-Rhythm." The Duffy String Band, formerly the old Fireman's band, is family run by descendants of Henry Kunzig. Ted Kudrick has been parading for half a century and has been captain of Duffy for more than 30 years, the longest still-serving captain at the end of the modern era. Above, Kudrick is with his son Jake in 2015. (PHL17.)

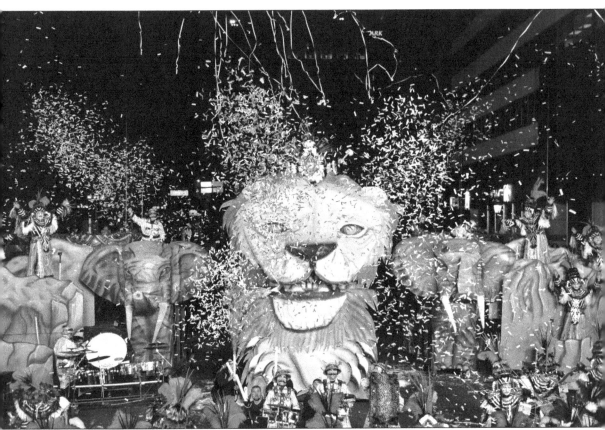

What the String Band Division presented on the street in the early 21st century was very different from what was seen in the 1960s. The music is more complex, musicians play while moving quickly, costumes are varied within each band, and the stage setting and the size and quality of the props are more theatrical and larger. Woodland String Band and captain Tom "Shaggy" Robison had a powerful visual ending in Woodland's 2012 first prize theme "It's a Jungle Out There." (Woodland String Band.)

Five

THE FANCY
BRIDGADE DIVISION

The Fancy Brigades are both old and new among Mummers, and in some ways, they have begun setting Mummery's direction. The brigades have existed since the mid-20th century, but they broke away from their Fancy Division mother clubs in the late 1970s to form their own division. Then, in 1998, they made the bold move to put on their shows, mainly indoors. The City of Philadelphia can guarantee tourists a Mummers show in climate-controlled comfort, and the brigades are boldly redefining Mummery. Golden Crown NYB's 2016 first prize winning theme was "A Scarecrow's Dream." (FBA.)

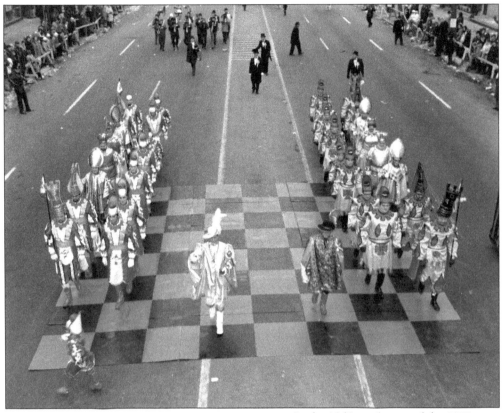

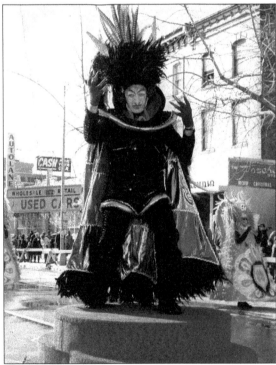

In the 1960s and most of the 1970s, the Fancy Brigades Division was a mix of clubs infused with the Fancy Division pedigree of feathers and grandeur with a touch of what was to come. Above, Golden Crown and legendary Mummer Joe Schubert used a chess board "stage" in 1970, finishing seventh, but otherwise looked traditional; the Joker's and captain Joe Walters's "Witch's Sabbath" theme, taking third prize in 1968, was a sign of things to come. (Above, Robert Finnigan; left, FBA.)

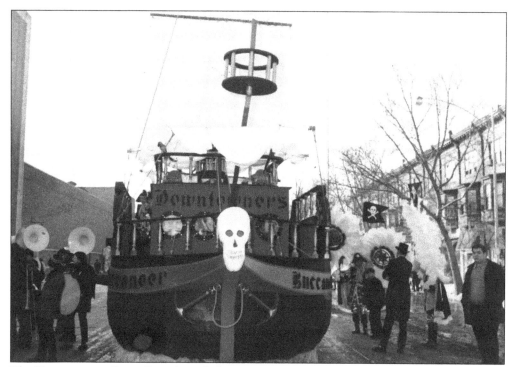

The Downtowners Fancy Brigade took first prize in 1971 with a pirate theme. This was an early large prop of the modern era. From the mid-1960s, the props grew in size, and later, so too did the Fancy Brigade Division. It rose to about 20 clubs by 1984, before dropping and leveling off to nearly a dozen clubs by 2016. A new club, Purple Magic, is set to perform in 2017. Below, captain Rich Lind and the 2nd Street Shooters, established in 1988, performed its "Mega Arcade Adventure" in 2016. Above, MM; below, FBA.)

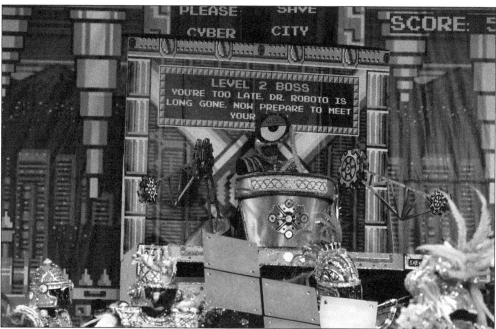

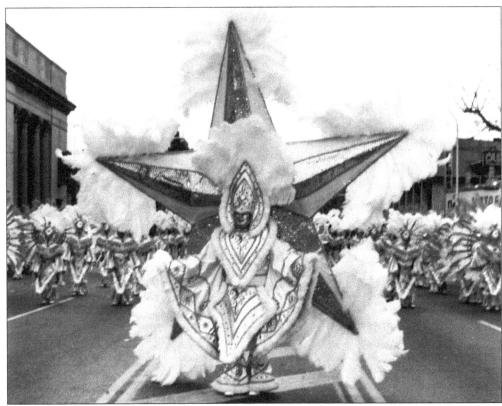

From the 1960s to the 1980s, clubs began gravitating toward more fantasy costuming. Above, the Merry Makers and Jack Cassidy with their "Super Star Rock Musical" theme are shown in 1978, and pictured below is the High Steppers and its theme "The Occult." The brigade movement remained mostly drill like. (Both, FBA.)

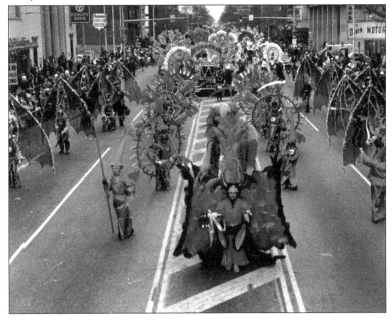

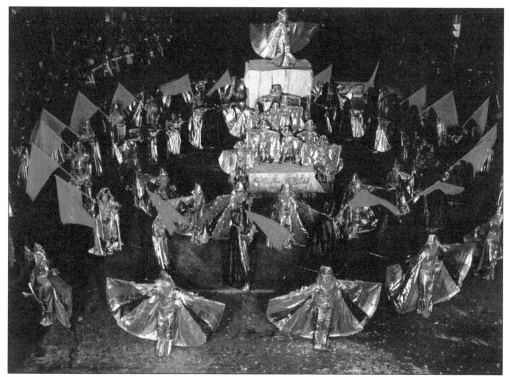

The Downtowners NYB and Bill Isaacs won first prize in 1979 with "Close Encounters of the Fantasy Kind," seen above. This embrace of fantasy would lead to performances like Clevemore's in 2013 with its theme "Alien Rising—Battle for the Power of the Frozen Planet." The Tursi family has led the Clevemore Fancy Brigade, named for the South Philadelphia corner on which it was founded, Cleveland and Moore Streets, since 1936. (Both, FBA.)

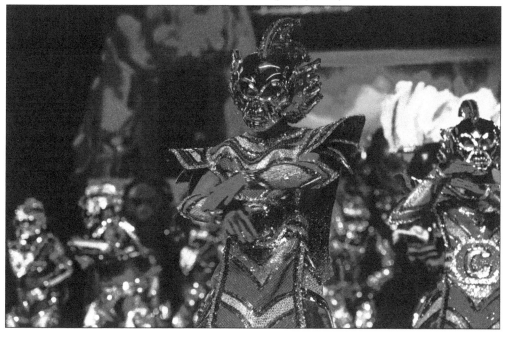

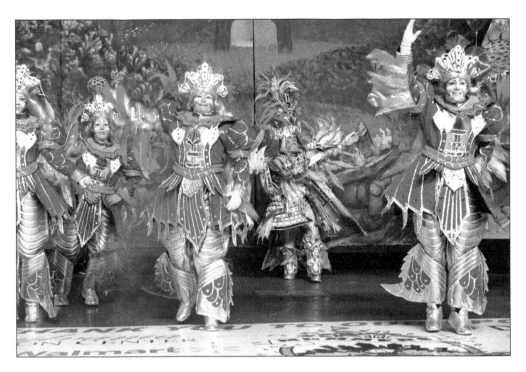

The brigades perform in 4.5-minute shows inside the Pennsylvania Convention Center, near the outdoor parade. These are high-energy performances with recorded music, usually pulsating techno pop or mystical music, setting the dancers' beat or mood amid multiple scene changes. The first woman captain in the brigades was Debbie D'Antonio, of the Hearts. Sunny McHale would lead an all-woman brigade called the Fancy Dolls in the 1990s. Today, clubs like the Avenuers (above) and captain Bob Fitzmaurice credit the influx of women with improving production and survival. The brigades, like Satin Slipper, can become a part of a person's life. So much so, that some say it in ink. (Above, FBA; below, SH.)

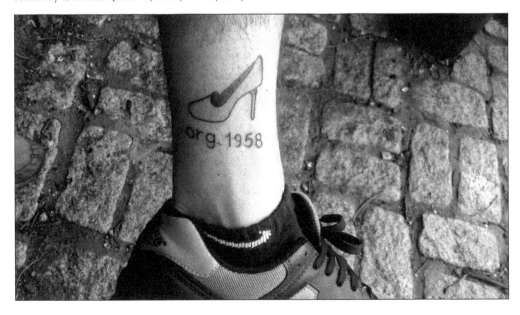

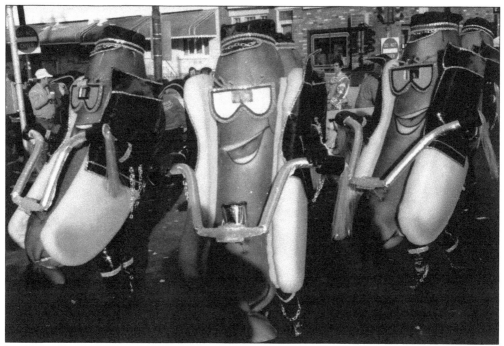

In the modern era, the Fancy Brigades could still be lots of feathers and big back pieces, or just humorous, as Saturnalian NYA was in 1988 with "Place Your Order." (MM.)

Near the end of the modern era, the brigades continued to evolve toward techy, edgy, apocalyptic, mystical, or magical themes. Saturnalian NYA and captain Jack Hatty Jr. performed this "Voodoo on the Bayou" theme. (FBA.)

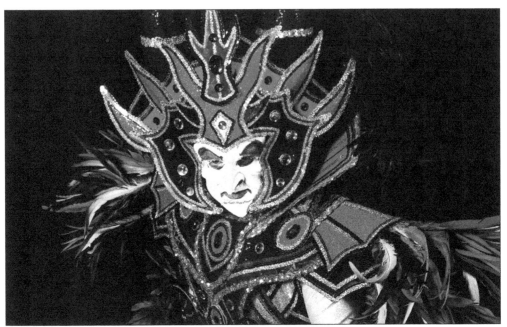

Bill McIntyre's Shooting Stars are the winningest Fancy Brigade. Shooting Stars captain Michael Adams's suit and makeup are typical of the best. (FBA.)

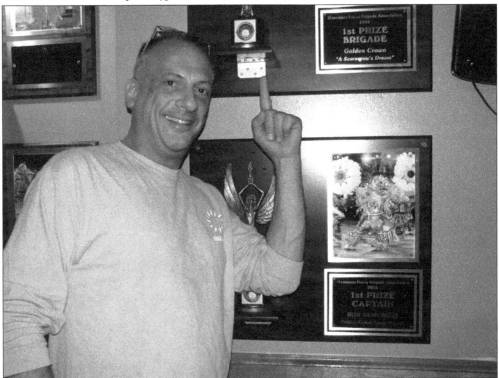

Designer and choreographer Todd Marcocci advised Golden Crown Fancy Brigade, which won in 2016. Marcocci also worked with Hegeman String Band for several years, stretching the boundaries of makeup, staging, and themes and spurring more use of technology. (SH.)

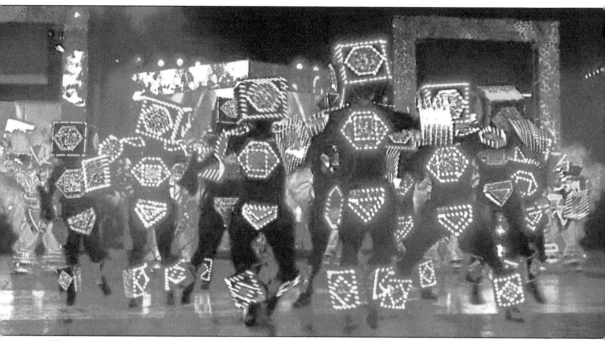

This is still folk art, but folks today are tech smart. The brigades in the early 21st century have been on the cutting edge of visual artistry, employing current video technology and mixing recorded images with live performance. The South Philly Vikings and captain Pete D'Amato are among the most successful. Above, the South Philly Vikings theme was "Ka 'Light' Oscope: Harness the Power of the Spectrum." (FBA.)

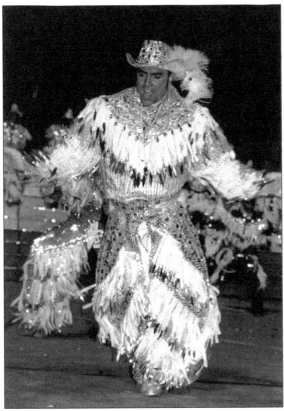

The South Philly Vikings, formerly the South Philly Comics, and Bill McIntyre's Shooting Stars have been chief rivals since the 1990s, along with the Jokers. One of the great entertainers among brigade captains in the modern era was the Joker's Fred Keller, seen here in "How The West Was Fun" in 1994. (Jokers, FBA.)

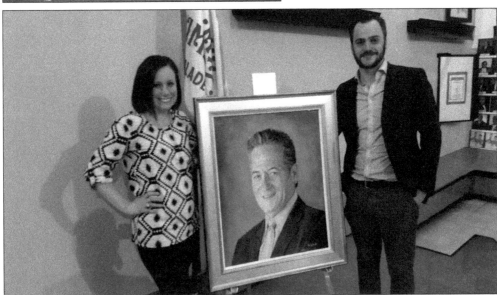

One of the most influential Mummers in the last half of the modern era was Jim Julia, president of the Fancy Brigade Association and former head of the Downtowners NYB. Julia is credited with bringing all the divisions together and with making the indoor show a success. He passed away suddenly in November 2015. His family, including daughter Meghan and son James Jr., helped dedicate a portrait in his honor at the Mummers Museum. (SH.)

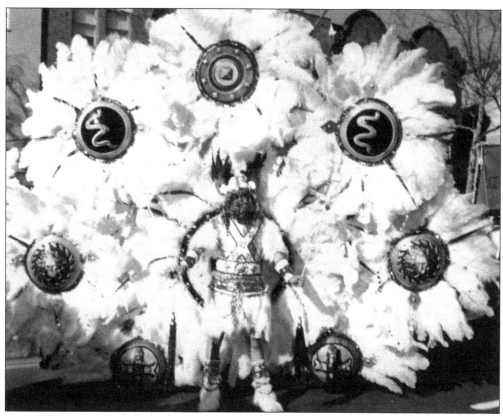

Before the development of the Fancy Brigade Division, Bill Isaacs, Joe Walters, and Bill McIntyre were among the most successful captains. Captains in the Fancy Brigades are larger than life figures. Above, Bill Dicks led the Vikings in 1973. A back piece that size today would most likely be too restrictive to wear. At right is John Bielec with Satin Slipper NYB. The club's theme in 1999 was "Land of the Rising Sun." (Both, FBA.)

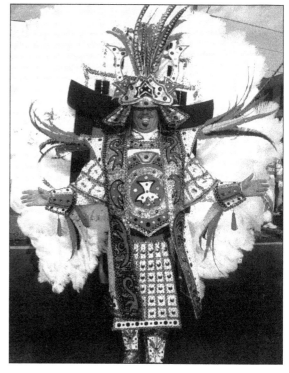

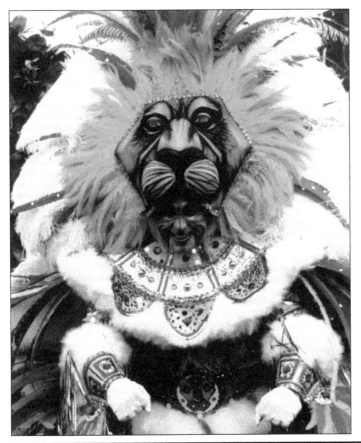

Mickey Adams (seen at left and the father of Michael Adams) of Bill McIntyre's Shooting Stars, along with Pete D'Amato (below) of South Philly Vikings, is the winningest captain since the division was created in 1978. Mickey Adams has nine First Prize Captains awards and nine first and six second prize club finishes in just two decades, starting in 1991. Still active, D'Amato to date has amassed half a dozen firsts in a dozen years. (Left, Robert Finnigan; below, FBA.)

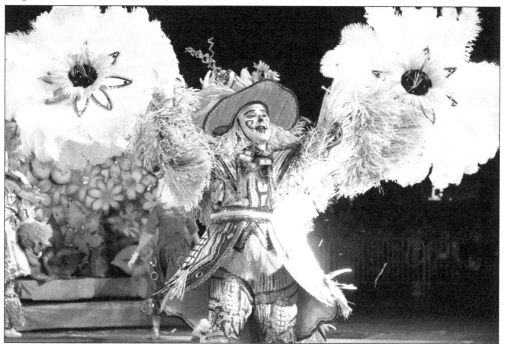

Much has changed. Joe Anderson Jr. with the Shooting Stars wore this Fancy-inspired suit seen at right in 1982. His wife, Cheryl, painted the mask. However, designers and costumers have become more involved and needed today for the fast-paced, Broadway-like mini shows that the brigades perform. Younger captains have begun moving into leadership in the brigades. In 2016, Rob Runowski (below) claimed the captain's first prize for his performance with Golden Crown. (Right, Anderson; below, FBA.)

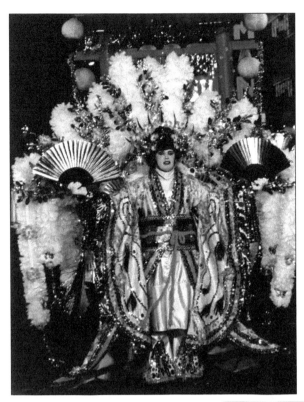

Golden Crown's former captain Bill Burke Jr. led his club to a first prize in 1983 with the theme "Cherry Blossoms on Parade." Burke has been the conscience of his club, the division, and Mummery for much of the modern era. As he stands in a second-floor window in 2016, next to the big number 1 sign adorning the Fancy Brigade's clubhouse, he appreciates the Mummers tradition of family; what it takes and what is gained in planning, rehearsing, and being together throughout the year; and performing in public on New Year's Day. (Left, Burke; below, SH.)

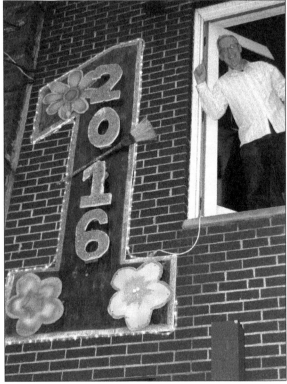

Six

CHALLENGE, OPPORTUNITY, AND GOODWILL

A Philadelphia Mummer has always felt challenged. But over most of the modern era, Mummery saw its large World War II generation retire and some members move away. Free time shrunk. Costs went up. In 2009, the City of Philadelphia, facing the loss of tax revenue in the wake of the Great Recession, eliminated prize money. The String Band Association midwinter fundraiser, the Show of Shows, ended in 2013. Mummery also faces increased scrutiny of bigotry in imagery, language, or themes. All this as society's entertainment choices have accelerated and broadened. About 15,000 Mummers performed in the 1980s. Today, the number is under 10,000. The parade had once taken more than 12 hours, but now the outdoor portion runs under seven hours, and the City of Philadelphia has quickened the pace of the parade, much to the dislike of older marchers. Efforts have been renewed to attract more African American (pictured above is a Murray entry), Asian, and Latino Philadelphians and to invite more of the LGBT community to take part openly in the annual event. Mummers also recently marched in the Philly Pride Parade. (MCC.)

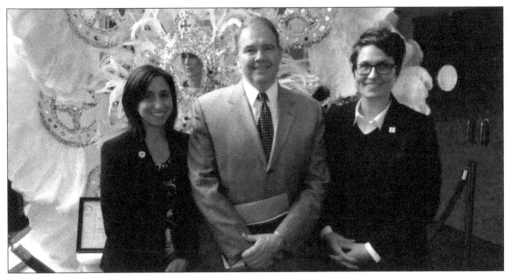

Mummery's future may be vibrant, though. It is still a substantial parade. The indoor show is successful. Mummers are increasingly sensitive to tourism needs. Weather-related postponements, which had averaged once every three years between the mid-1960s and 1990s, have became rarer in the last 20 years. Human rights officials and Mummers are working together on education and other steps to prevent hateful occurrences, as well as robust responses if they occur. Pictured above are, from left to right, Rue Landau, executive director of the Philadelphia Human Relations Commission; parade director Leo Dignam; and Nellie Fitzpatrick, director of LGBT affairs for the Office of Mayor. (Mayor James Kenney used to strut with the Joker's NYA.) The once four-mile parade route had been changed and reduced several times to accommodate construction, fewer parade watchers, and the needs of tourism. In 1995 and again from 2000 to 2003, the parade was on Market Street. Though back on Broad Street, the route in 2015 was shortened again to just over a mile and reversed, starting near city hall and stopping not long after it leaves the Center City hotel district. (SH.)

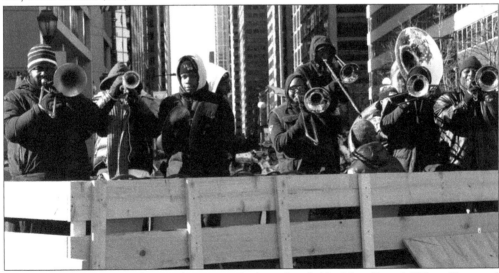

As the 21st century unfolds, popularity rises for brass bands like New Sound, Whoa Phat, and others, some all African American and some from New Orleans, accompanying the large Wench Brigades. (PHL17.)

An effort is under way to restore prize money and revive the indoor Show of Shows in Philadelphia. SugarHouse Casino has become the lead private sector supporter. Above, general manager Wendy Hamilton (center, in pink) and city councilman Mark Squilla (far right), a member of the South Philly Vikings, are pictured at the casino's expansion dedication in 2016. Below, Bucks County–based Uptown String Band and captains like Jamie Caldwell and Ryan Radcliffe often emphasize humor, reflecting many Mummers who simply want to spread the joy of Mummery. (Above, SH; below, PHL17.)

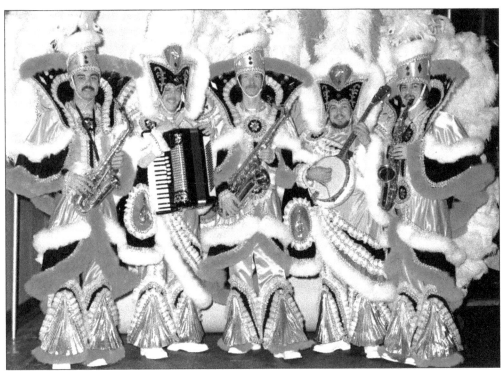

A common technique in Mummery is to create a visual wall and fill empty spaces. Pictured are Bill Gerner (above left) and other members of Aqua String Band in 1979. This imagery is symbolic of the loyalty and pulling together as a family that many Mummers believe and practice. The nonprofit Save The Mummers, later called Love The Mummers (LTM), was formed in 2009 during the Great Recession. LTM president George Badey (below right) and US representative Robert Brady (below left), who started the Philadelphia Traditions Fund benefiting cultural celebrations, note that the Mummers bring in millions of dollars in tax and business revenue to the city. (Above, William Gerner; below, George Badey.)

Mummers also support many
charitable causes, such as Autism
Awareness, the Police Athletic
League, children's hospitals, and
Easter Seals. They visit the ill in
their homes or in hospitals. Above,
Deb Theurer-Tomaselli and Mike
Tomaselli have been running
Mummers Against Cancer since 2006,
with the proceeds benefiting the
American Cancer Society or Mummer
families fighting illness. (SH.)

Murray members send care packages
to US Armed Forces personnel.
Woodland String Band holds an
annual blood drive for the American
Red Cross. Megan West McFarland,
of Cara Liom, a Wench Brigade,
founded Mums and Mutts to rescue
animals. (Megan West McFarland.)

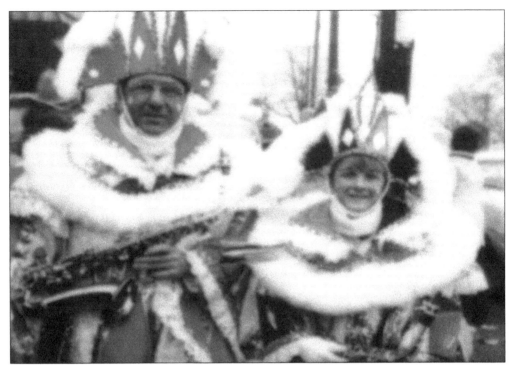

The foundation of Philadelphia Mummery is the joy of celebration and of being together with family and lifelong friends. Common touch points like school, church, or work expand the circle. It is a tradition that binds people, as with a young future Quaker City String Band president Harry Brown Jr. (right) and his father (left). Mummery strengthens many families. (Harry Brown Jr., Quaker City String Band.)

Mummers celebrate each other's life events. Hundreds of people, even thousands, attend a Mummer viewing or funeral, strutting into heaven a beloved Mummer, such as Joseph "Pop" Bryson, the 81-year-old patriarch of the Bryson NYB in October 2014. (David Grzybowski.)

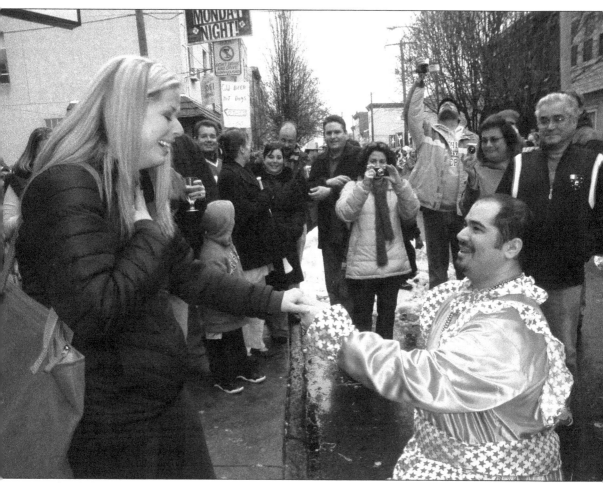

The Philadelphia Mummers are gradually entering a postmodern, ever-deepening digital era. How millennial and younger generations shape Mummery will depend on family ties, where they live, how much they have to work, and what costs and time demands can be handled. But Mummers also believe it will rest on how entertaining 21st century Mummers can be and whether legacy Mummers and new citizens can appreciate each other within the framework of Mummery. It may be an opportunity. Above are Angela and Jeff, two young people on South Second Street in South Philadelphia, one of them in the fantasy costume he wore the day they met a few years earlier. Together, they make a momentous decision. Many wonderful "Mummeries" are yet to be made in the City of Brotherly and Sisterly Love. (Jeff Pupo.)

Visit us at
arcadiapublishing.com

CPSIA information can be obtained
at www.ICGtesting.com
Printed in the USA
BVHW061945171122
652194BV00005B/340

9 781540 214249